THE MUSEUM OF MODERN ART OXFORD

S O V I E T

S O C I A L I S T

R E A L I S T

P A I N T I N G

1930s - 1960s

Paintings from Russia, the Ukraine, Belorussia, Uzbekistan, Kirgizia,
Georgia, Armenia, Azerbaijan and Moldova selected in the USSR by
Matthew Cullerne Bown

FOREWORD

The survival of works of art in the Soviet Union has often been a matter of chance. An icon was liable to be conscripted for target practice by the Red Army during the civil war. A neo-classical statue risked losing an extremity or two to the hammer-toting supporters of a proletarian art in the 1920s. An avant-garde painting probably spent fifty years after about 1930 hiding under a carpet because it was a dangerous bourgeois influence. And even works of Socialist Realism, brought into the world between about 1932 and 1956, were liable, as Stalin's legacy was progressively dismantled, to have been painted over, consigned to crumble and crack in dusty overheated storerooms or, if big enough, used to mend a roof on a collective farm.

Most of the paintings assembled in this exhibition have come from artists' studios, where serious works of Socialist Realism are scarce. Not only has the process of de-Stalinisation initiated in 1956 led artists or their families to destroy or dispose of them; but nearly all of an artist's production, commissioned and paid for by the State, left the studio on completion, bound for hospitals, factories, schools and museums. But this process of selection from studios has enabled us to provide a perspective on artistic life across the whole of the USSR that few Soviet museums could match. Paintings from most of the Soviet republics are included in the exhibition. They demonstrate the attempt that Stalin made to homogenise very different cultures; an attempt which has ended in tragic outbreaks of ethnic conflict all over the USSR. If we have anything to learn from the tremendous event that was the Soviet Union, then surely the futility of trying to impose a single culture on different peoples is lesson Number One.

This exhibition could not have been mounted without the assistance of many people in the USSR and the UK. We would like to thank in particular Natasha Nebeliouk, who worked enthusiastically for three years on all aspects of the show, opened doors locked by Soviet bureaucracy and did more than anyone to make the whole enterprise possible; the USSR Ministry of Culture for its help with export formalities; Mikhail Mikheev, Tair Salakhov, Mikhail Kursanov, Oksana and the staff of the USSR Artists' Union for their constant hospitality; Georgi Leman, Eduard Bragovski, Valeri Pedus, Pavel Ivanovich, Dima Shilkin and the painting section of the Moscow artists' union for digging out a number of paintings; the artists' unions of the Ukraine, Belorussia, Georgia, Azerbaijan, Armenia, Uzbekistan, Kazakhstan, Moldova and Latvia for their hospitality; Ala Borisenko, for her valuable liaison work in Moscow; Aleksandr Sidorov, for his essay and help with the catalogue; Jokka Teutscher and Tony Reeve for their restoration work; David Thorp and *The Showroom* for logistical support; and Uldis Salaks, frame-maker to Brezhnev, who has carved some extraordinary frames especially for the exhibition.

We gratefully acknowledge the financial support of Visiting Arts.

Finally, we would like to thank all those artists and their families who have given of their time and effort in the search for pictures for this exhibition. We extend our apologies to those who must be disappointed because, for reasons of space, we have been unable to include in the exhibition all the works that were initially selected.

Matthew Cullerne Bown
David Elliott

Exhibition
January 12 - March 15 1992
Oxford

ISBN: 0905836 76 6

Registered Charity
The Museum of Modern Art receives financial
assistance from the Arts Council of Great
Britain, Oxford City Council, Oxfordshire County
Council, Visiting Arts and Southern Arts
Recipient of an Arts Council Incentive Funding
Award

CONTENTS

Plate I

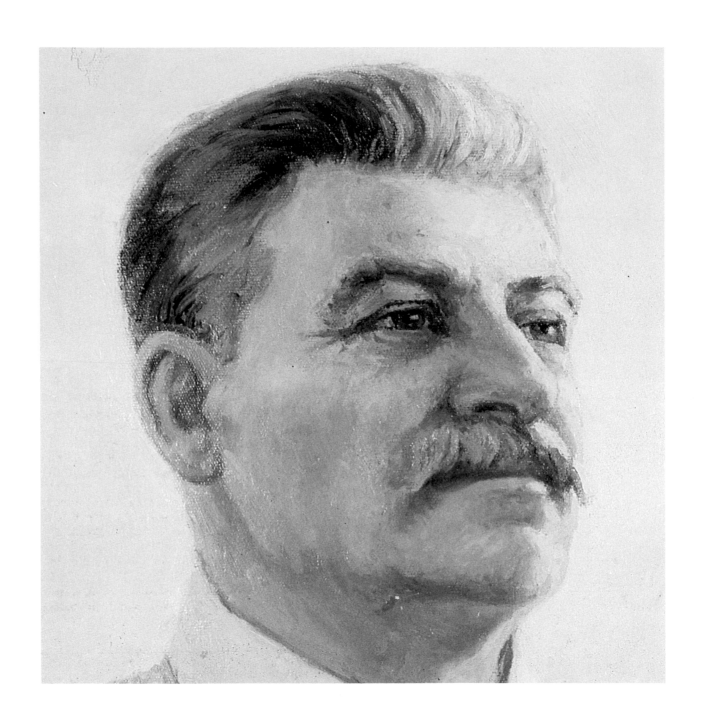

FYODOR SHURPIN
Detail from *The Morning of Our Motherland*
Oil on canvas, 167 x 232 cms (66 x 91 ins) (whole)
1948

ENGINEERS OF THE HUMAN SOUL

P A I N T I N G O F T H E S T A L I N P E R I O D

David Elliott

In Moscow during the late summer of 1934 the basic tenets of Socialist Realism were laid down at the First All-Union Congress of Soviet Writers. Andrei Zhdanov, Secretary of the Communist Party, Stalin's future son-in-law, cultural boss and orchestrator of the congress gave the keynote speech. They were meeting at a time when Communism had gained '... a final and complete victory ... under the leadership of ... our leader of genius, Comrade Stalin (*loud applause*). Advancing from milestone to milestone, from victory to victory, from the Civil War to the time of reconstruction, from the time of reconstruction to the period of the socialist reconstruction of the entire national economy, our Party has led the country to victory over the capitalist elements within it and has expelled them from all areas of the economy.'[1]

The struggle had been long; the first Five Year Plan had been completed one year early in 1932, and a second was now underway. Zhdanov was echoing here the sentiments expressed at the 17th Party Congress held in January 1934 which had celebrated the defeat of the enemies of Socialism in the USSR and was known as The Congress of Victors. Triumphalism had become the new cultural order:

In our hands we hold a sure weapon...the great and invincible doctrine of Marx-Engels-Lenin-Stalin ... (This) great banner is victorious.[2]

Under the banner of determinism, victory seemed inevitable as it emanated from the supremacy of the Party, yet it could only be maintained through a process of struggle. Zhdanov's address to the writers'

congress was the culmination of a long line of Bolshevik pronouncements and decrees on the arts which now became enshrined within the monolithic structure of State Socialist Realism. Literature was regarded as the most articulate of the arts and it was understood that what was decided here would soon become the rule for the whole of Soviet culture.

The impetus for this move had come directly from the leader: at a secret meeting of writers held in Maksim Gorki's flat in the early hours of 26 October 1932, Stalin, not previously known as a critic of the arts, had informed the assembled group that the historical moment demanded that the Soviet writer should become 'an engineer of the human soul.'[3] Zhdanov now quoted the General Secretary's words and explained to the congress what they meant:

Firstly, we must know life in order to be able to depict it truthfully - not scholastically, lifelessly or merely as 'objective reality'; we must depict reality in its revolutionary development.[4]

An acceptable and plausible subject and a truthful depiction had now to be combined with the vision of ideological transformation under State Socialism. This was the method by which an artist could create work which met the challenge of a rapidly evolving society; no specific style was prescribed as a means to this end.

Some artists such as Isaak Brodski, Igor Grabar or Aleksandr Gerasimov, who had been in close touch with the Party and its luminaries, had already anticipated this pronouncement in their work. But a new

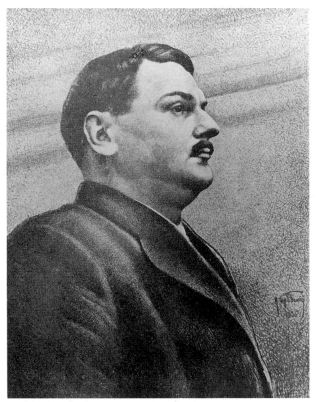

ISAAK BRODSKI
A. A. Zhdanov
Lithograph, 83 x 63.5 cms (33 x 25 ins)
1935
I. I. Brodski Museum-Apartment, St. Petersburg

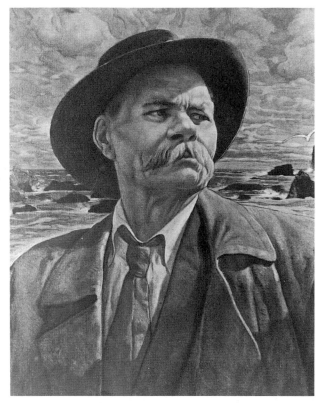

ISAAK BRODSKI
Maksim Gorki
Oil on canvas, 132 x 107 cm (52 x 42 ins)
1937
Tretyakov Gallery, Moscow

attitude was now demanded from all artists which would break with the romanticism, escapism and utopianism of the past; the artist of the future had to be in harmony with the ideals and aims of the Party. Heroism and self-sacrifice were necessary virtues for sustaining the struggle.

Just under three hundred interventions by Soviet and foreign guests followed the set speeches by Zhdanov (Ill. 1) and Maksim Gorki (Ill. 2); only one of them was by a visual artist, the critic, painter and administrator Igor Grabar (Ill. 3). Yet no consensus emerged as to exactly what an Engineer of the Human Soul could, or could not, do, as no positive guidelines for style or subject-matter were laid down. Instead, the understanding of what constituted Socialist Realism in literature and throughout the arts evolved negatively as part of a process which had been set in motion in 1928 at the start of the Cultural Revolution.[5] Cultural pluralism was consigned to the past; artists were now encouraged to think along the same lines, to submit their work for criticism by their fellows and to make amendments should it be found wanting. Above all, their work had to be politically correct. If they transgressed, were suspected of doing so, or were discovered to have deviated at some time in the past, they became outcasts, shunned by former friends and associates. As Stalin's Terror gained momentum they, along with many other sectors of society, became increasingly vulnerable to summary arrest, incarceration or ex-

ecution.

In spite of its incontrovertible observance by the majority of artists working throughout the USSR, the doctrine of Socialist Realism had no visible means of conceptual support other than a blind belief in the justness of every action of the Communist Party and, in particular, in the increasingly irrational and dictatorial judgement of Iosif Stalin, its General Secretary.

Zhdanov's distinction between old-style utopianism and the new revolutionary romanticism did not bear scrutiny as the products of Socialist Realism were, in their way, just as visionary as those of the avant-garde artists who were now vilified. Paradoxically, the image of the artist-engineer itself was rooted in this much despised past: in the Constructivism developed by Tatlin and Rodchenko in the years immediately following the Revolution. During the 1920s these artists and Productivists such as Liubov Popova, Varvara Stepanova and Anton Lavinski took this idea further by ceasing to work as artists to take up employment as designers in factories. Avant-garde literature and theatre also were influenced; writer Aleksei Gastev, director of the Central Institute of Labour, and theatre director Vsevolod Meierhold both adapted the cybernetic theories of the American industrial consultant, Frederick Taylor, in their work and Sergei Tretyakov, playwright, critic and editor of *Novy LEF*, decribed the role of the artist as a 'psycho-engineer.' Under Stalin the work of these artists fell into neglect and Gastev,

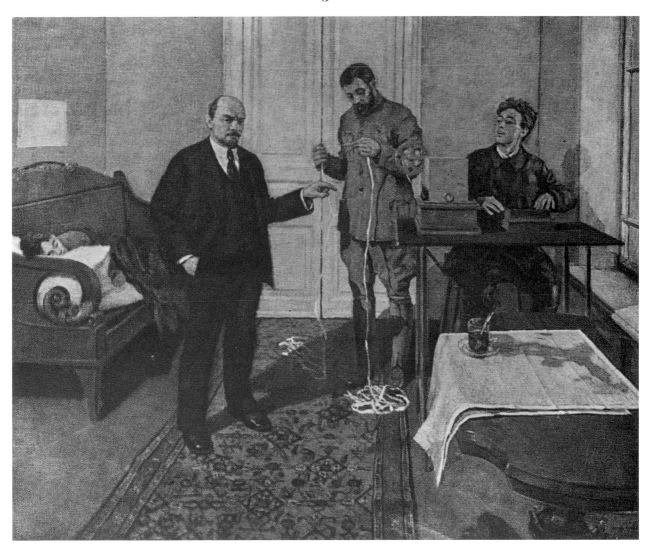

IGOR GRABAR
Lenin at the Telegraph
Oil on canvas, 150 x 200 cm (59 x 79 ins)
1927-33
Central Lenin Museum, Moscow

Meierhold and Tretyakov were all murdered in the purges.

During the 1920s it had been possible for such artists to be sustained by the modernist fantasy that as men and women of the future they were actually engineers in a new symbiosis of aesthetics and technology. This would provide a firm foundation for building the future and would render obsolete the previous separations of art, science and industry.

For Stalin, the engineer also had a symbolic as well as practical significance, but his definition was more down to earth and rooted in present needs. Without them Russia could not embark upon the struggle of building the heavy industry which it needed and which was a lynchpin of the Five Year Plans. In the new society Stalin created the engineer became the intelligensia and elite of the industrial working class, the loyalty of which had to be assured. This became clear from the outset; it is no coincidence that the

Shakhty Affair, the first of many show trials, took place in 1928 soon after Stalin, General Secretary of the Party, had begun to take command. Fifty-three engineers and technicians in the coal industry were prosecuted for alleged sabotage, wrecking and espionage.

Obedience and loyalty were necessary for survival, yet not even sycophantic adulation could ensure indemnity from Stalin's paranoia or from his cold blooded calculation that everyone except himself was expendable. A servile Press flattered their leader with many hyperboles; he was 'our father', 'a shining sun', 'the staff of life', 'a great teacher and friend', and 'the steel colossus'. But in the field of the arts one more could be added; the priorities of heavy industrial production were easily adopted when Comrade Stalin became 'the aesthetic engineer'.

 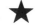

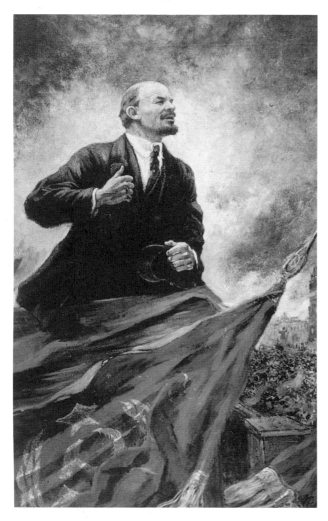

ALEKSANDR GERASIMOV
Lenin on the Tribune
Oil on canvas, 288 x 177 cms (113 x 70 ins)
1929
Central Lenin Museum, Moscow

The theoretical base of Socialist Realism may be traced back to 1905 when Lenin wrote his essay 'On Party Organisation and Party Literature'.[10] This was selectively and misleadingly appropriated by the Party in the 1920s and 1930s to validate its move to control the arts. Lenin had conservative tastes and disliked Futurism and the avant-garde intensely; but it is to his credit, as well as to that of Anatoli Lunacharski, the Minister of Education, that in the years following the Revolution the avant-garde was subsidised along with more traditional groups. After the inauguration of the First Five Year Plan in 1928 this support was withdrawn.

The survivors of The Itinerants who had remained in Russia organised one group exhibition after the Revolution and then merged in 1923 with *AKhRR* (The Association of Artists of Revolutionary Russia), an organisation of committed realist artists which had been formed during the previous year. *AKhRR* had an active programme which was based on the depiction of the Soviet masses and their institutions as well as on grass-roots contacts in clubs, factories, barracks and other places of work. It showed life in the Red Army, especially its actions during the Civil War, the new militia force and judicial process, the Soviet literacy campaigns and medical innovations as well as the new Workers' Faculties (*RabFak*) which were attached to schools and universities. It also supported national traditions and, unlike other groups of realist painters working at the time, strongly criticised modernist developments in French and German art.[11]

During the late 1920s both Isaak Brodski and Aleksandr Gerasimov, who were both members of the Association, worked on *grandes machines* which depicted key events in the history of the Party: *The Shooting of the 26 Baku Commissars* (1925); *Lenin's Speech at the Putilov Factory in May 1917* (1929); *Lenin on the Tribune* (Ill. 5) and *Lenin at Smolny* (1930) were typical subjects. They also developed a close friendship with Kliment Voroshilov who, from 1926, was head of the Red Army and provided a direct line of communication to the Central Committee. Stalin is on record as only having attended two art exhibitions in his adult life and the first of these was that organised by *AKhRR* in 1928 in commemoration of the Tenth Anniversary of the Red Army.

In 1928 the Cultural Revolution co-incided with a move away from the pluralist economy and culture of the New Economic Policy (*NEP*) towards centralised state planning in all spheres of life. Stalin wished to encourage an activist mentality thoughout Soviet society and to ensure that the sudden increase of workers in the new industries was reflected by an equally dramatic growth in party membership.[12] Class credibility and party loyalty now became vital indicators in a cultural climate of workerist ideals which inverted the previous social structure to put the proletariat at its head. Instead of being given clubs or reading rooms as before, the workers now would build palaces.

AKhRR played an important part in this process; the crackdown started in Leningrad. In June 1926 an article entitled 'A Monastery on a State Subsidy'[13] denouncing the work of Malevich and his colleagues at *GInKhuK* (State Institute of Artistic Culture - a research body) appeared in the party newspaper; soon after the Institute was shut down. In July, Vera Ermolaeva, head of the colour laboratory at *GInKhuK*, wrote to Mikhail Larionov, then living permanently in Paris: '... *AKhRR* is taking over completely. *AKhRR* art is the official art ...While *AKhRR* is given two hundred lines in the newspaper we are given none. *AKhRR* has had an exhibition of over 2,500 canvases on the premises of the Agricultural Fair in Moscow for a whole year. *AKhRR* is opening up studios in every city and in the capitals of every district and gets state funding, it sends artists all over the country to paint the ways of life of the peoples of the USSR.'[14]

In the following year, 1927, on return from a visit to Berlin for an exhibition of his work, Malevich was arrested and imprisoned for three months by the NKVD (secret police) on the charge of being a German spy. He was to die of natural causes in 1935 before the purges started in earnest, but not before Ermolaeva and four of her colleagues were arrested and imprisoned in December 1934 in the repression which imme-

diately followed the assassination of Kirov.[15]

In 1928 *AKhRR* changed its name to *AKhR*, (Association of Artists of the Revolution); this coincided with a younger generation of monumental artists taking control who fought the corner of proletarian interests in the visual arts just as other young activists were taking control of literature, film, theatre, architecture, music and photography. Public and monumental art now became the main plank of *AKhR* and such successful easel painters as Brodski, who before the Revolution had been a member of the 'bourgeois' World of Art group, were expelled for 'naturalism' and their lack of proletarian commitment. The broad-based and widely distributed journal of the group, *Art of the Masses*, was now replaced by a less conservative, better designed and more tendentious magazine entitled *For a Proletarian Art* (Ill. 6).

The proletarian groups took a number of ideas from the avant-garde as well as their taste for extremism. The design of their magazine went through a period of Constructivism and, for a time, the neo-Suprematist motif of a flat coloured square was used as a logo. In common with the Productivists before them, they propagandised on behalf of art which was agitational and could be mass-produced: posters, murals, cartoons, caricatures, models for street demonstrations and textiles with revolutionary designs. They were not yet entirely closed to outside influences and published the work of artists from other sympathetic groups.[16]

In March 1931 the Association went through a further transformation. Following a directive for in-creased political action, the party members of *AKhR* reformed the group as *RAPKh*, the Russian Association of Proletarian Artists; the close identification with the achievements of the Five Year Plan was intensified. Criticism of its own members as well as of non-proletarian groups became virulent; the atmosphere of a witchhunt spread across the country.

The end of the Plan was in sight, completion would be in four years instead of five; the pluralist infrastructure of the 1920s had been broken down and the zealots of proletarian art were in danger of devouring their own children. Accordingly, in April 1932, the Party issued a decree 'On the Reformation of Literary-Artistic Associations' which dissolved all existing artistic groups.[17] Their members would now be subsumed within single unions for individual art forms under the supervision of the Party. A national union for the visual arts was not created until 1957 but, until that time, its function was effectively carried out by the Moscow Section of the Union of Soviet Artists (*MOSSKh*).[18] This provided not only ideological direction and a minimal income, but also access to materials and work space and, through other organisations, the possibility of commissions. The avant-garde was starved of the means to live unless it renounced the past and, with the vigour of a convert, blindly followed the party line.

The art press had been effectively dissolved in 1932 along with the groups which had published the magazines. In 1933 two new national journals, *Iskusstvo* (*Art*) and *Tvorchestvo* (*Creativity*) (Ill. 7) were brought out under the auspices of *MOSSKh*. For the next seven

6

7

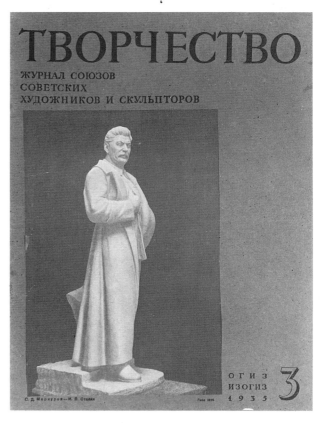

Cover of *Za Proletarskoe Iskusstvo* (*For a Proletarian Art*), January 1931

Cover of *Tvorchestvo* (*Creativity*), March 1935
Illustrated is one of many statues of Stalin by
Sergei Merkurov

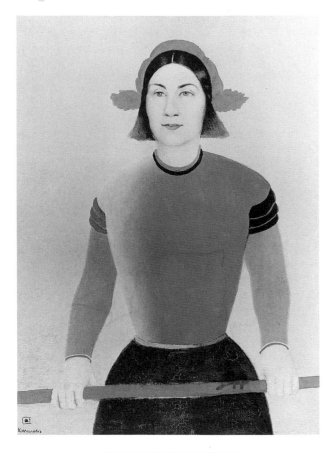

KAZIMIR MALEVICH
Girl with a Stick
Oil on canvas, 71 x 61 cms (28 x 24 ins)
1932
Tretyakov Gallery, Moscow

years, until he was sacked for showing an interest in French Impressionism, Osip Beskin, an editor of both magazines, was an arbiter of correctness in the visual arts. If artists hoped that the new decree of the Central Committee had brought the period of proletarian hysteria to an end, they were soon to be disabused of the fact; worse was to follow. Beskin's book, *Formalism in Painting*, published in 1933, which denounced the work of tens of painters, was a useful tool for locating enemies.

The exhibition, Artists of the RSFSR: 15 Years, which opened at the Russian Museum in Leningrad in November 1932 and then travelled to Moscow in the summer of the following year, came at a turning point. In the Leningrad showing, avant-garde works by Malevich (Ill. 8), Pavel Filonov and others were included as part of a comprehensive account of the art that had been made in those years. By the time the exhibition travelled to Moscow the amount of avant-garde work had been reduced significantly and what was included was shown in a separate space with denunciatory texts beside it.[19]

The process of isolation continued until 1936, the year of the first show trial of the Great Purge, when all works which were not viewed as prime examples of Socialist Realism were removed by the newly formed KPDI (Committee for Art Affairs) from display in public collections. Zhdanov waged a campaign against formalism across the arts in a series of articles in *Pravda*, the party newspaper. In an article entitled 'Noise instead of Music', Dmitri Shostakovich's recent opera *Lady Macbeth of Mtsensk* was described as '... unsoviet, unwholesome, cheap, eccentric, tuneless and leftist.' Another article attacked the work of dramatists, invoking 'the complex richness of Shakespeare' as an example to be followed. A final article, entitled 'On Artist-Daubers', denounced the childrens' book illustrations of Vladimir Lebedev for 'bourgeois formalism'. Lebedev worked in Leningrad and had been one of the first artists to work on pro-Soviet propaganda after the Revolution; he had subsequently established himself a leading painter and illustrator who was internationally respected for the quality of his work. A reputation abroad may have been one reason why figures such as he and Shostakovich were chosen for such treatment.

The Terror only served to re-inforce the ideals of Socialist Realism. In 1938 Aleksandr Gerasimov gave the following analysis of the situation at a meeting of the Moscow union of artists: 'Enemies of the people, Trotskyist-Bukharinite rabble, Fascist agents who have been active on the art-front and have attempted in every way to brake and hinder the development of Soviet art have been unmasked and neutralised by our Soviet Intelligence Service ... This has made the creative atmosphere more healthy and has opened the way to a new wave of enthusiasm among the entire mass of artists.'[20]

After the war, more enthusiasm was shown when culture again was purged. In 1946 Zhdanov started where he had left off by orchestrating a series of decrees against formalism in literature, theatre, film and music which were published in *Pravda*. The rule of thumb definition of Socialist Realism as 'socialist in content, national in form' abetted a xenophobic campaign against 'cosmopolitan' elements - intellectual wreckers in this case rather than industrial saboteurs. Foreign and non-Russian influences were immediately suspect and French Impressionism - much-loved by artists themselves - was regarded as a form of decadent imperialism. Public displays of French Impressionism and Cubism, privately collected before 1917, were closed. Under this covert revival of Russian nationalism, the spectre of anti-semitism also lurked and many artists were persecuted because of their Jewish origins.

At the end of the 1930s a system of state honours had been put in place which was intended to encourage desirable tendencies in the arts. The lucrative Stalin prizes (first and second class), awarded for the first time in 1941, served as an example for other artists; and in 1947 a new Academy of Arts of the USSR was formed, based on the model of the old Imperial Academy. Its first president was Aleksandr Gerasimov. Such institutions rapidly became repositories for heroes; artists who took as their subject the image and persona of the great leader stood the best statistical chance of gaining an award.[21]

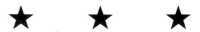

As Socialist Realism was a method of creation rather than a style, its theorists concentrated on abstract definitions of the kind of political consciousness that art had to reflect and through which its success or failure could be judged. The first of these, *narodnost*, centred around the relationship of the work to popular ideas and sentiments as well as to the ethnic origins of the people it depicted. *Klassovost* related to the class awareness of the artist and how he or she had depicted such concerns. *Partiinost* was the expression of the central and leading role of the Party in all aspects of Soviet life, and *ideinost* was the introduction of new thinking and attitudes, first approved by the Party, as the central content of the art work. Lastly, there was the concept of *tipichnost*, the typical nature of the situation and types portrayed; this concept was particularly applicable to the kind of domestic genre painting which developed during the late 1940s and had something in common with the theory of *typage*

9

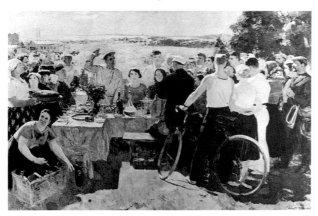

SERGEI GERASIMOV
A Collective Farm Festival
Oil on canvas, 234 x 372 cms (92 x 159 ins)
1936-7
Tretyakov Gallery, Moscow

10

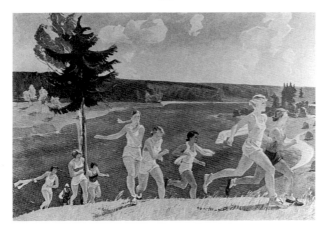

ALEKSANDR DEINEKA
Freedom
Oil on canvas, 204 x 300 cms (80 x 118 ins)
1944
Russian Museum, St. Petersburg

which Sergei Eisenstein had developed in cinema during the mid-1920s.

Such ideas are all admirably illustrated in Aleksei Vasilev's *They are Writing about Us in 'Pravda'* (Plate XXVIII), which was painted in 1951. Vasilev lived in Kishinev, the capital of recently-annexed Moldavia, and the peasants on the collective farm (*kolkhoz*), who are the subject of the painting, are located ethnically, as well as actually, by the traditional Moldavian rug on which they are sitting. In the individual studies of people who are enjoying a lunch break during the harvest, the concepts of *narodnost* and *tipichnost* are communicated; their labour as farm workers categorises their *klassovost* and the role of the Party (*partiinost*) is tacit in their being on a *kolkhoz* and overt in the title of the painting itself, which refers to an article they are reading in *Pravda*, the party newspaper, about the achievements of the farm. The *ideinost* in the painting refers back to the economic success which has warranted the newspaper article in the first place.

Although different styles of painting did develop under the umbrella of Socialist Realism, these grew out of the different genres, based on the traditional subjects of art, as well as out of the artists' own interpretations of party directives. As we have already seen, the Cultural Revolution was characterised by a battle of styles; this ranged from Georgi Rublyov's consciously primitive *A Factory Party Meeting* (Plate IX) to Mitrofan Grekov's romanticised depictions of the campaigns of the First Cavalry Regiment during the Civil War. The Civil War was a popular subject in art, literature and film at this time as it was regarded as the crucible out of which the Soviet State had been created and was therefore analogous to the period of intense struggle which now characterised the Five Year Plan.

The building of heavy industries also quickly became one of the staples of socialist realist imagery; the smoking chimney-stack and burgeoning power-station were symbols of optimism rather than pollution. But it was not until the mid-1930s, when memories of the carnage which had been effected by collectivisation in the countryside had begun to fade, that the image of a smiling and fertile peasantry on the *kolkhoz* began to be widely depicted (Ill. 9).[22]

Official taste became increasingly prudish, and the open sexual morality favoured in the 1920s by Aleksandra Kollontai, as well as by some members of such avant-garde groups as *LEF*, were denounced as utopian.[23] In 1936 abortions were banned in an effort to increase the population; as a result, the subjects of maternity and childhood became increasingly common in art. In the depiction of rural subjects the bounty of the land was often combined in pathetic fallacy with the fertility of the people who worked on it. The genre of the nude was replaced by that of physical culture (Ill. 10) and from the early 1930s the image of young, healthy bodies in - or just out of - sports gear became one of the few acceptable public expressions of Soviet eroticism. In Socialist Realism everyone and everything was idealised. A testament to ideology rather than reality, the new Soviet person, healthy, confident and optimistic, would, through the science of Eugenics, become the apotheosis of the working class. Only artists as established as Aleksandr Gerasimov dared to

VLADIMIR SEROV
The Entry of Aleksandr Nevski into Pskov
Oil on canvas, 287 x 492cms (113 x 194 ins)
1945
Russian Museum, St. Petersburg

paint the nude for its own sake (Plate XXV).

Historical paintings were initially confined to the depiction of iconic moments in the history of the Bolshevik Party, however from 1936, coinciding with the prosecution of the Great Purges, the frame of historical reference was widened to include selected great personalities of Russian culture. For two years the national spirit was redefined by major exhibitions of the work of the leading artists of The Itinerants: Ilya Repin, Vassily Surikov, Ivan Kramskoi and Isaak Levitan. The Press covered these exhibitions extensively and, on one occasion at least, they also became a subject for a contemporary artist: Gavriil Gorelov's *Red Army Soldiers in the Tretyakov Gallery at an Exhibition of Pictures by Repin* (Ill. 4) killed at least three iconographical birds with this single stone.

In 1937 a huge Centenary Exhibition was organised in commemoration of the birth of Pushkin, and the following year saw three more major exhibitions which showed contemporary art: the twentieth anniversary exhibitions of the Workers' and Peasants' Red Army and the All-Union Leninist *KomSoMol* and the celebratory Industry of Socialism. At this time a number of large art exhibitions were also being organised in the other republics of the Soviet Union.[24] This intensification of cultural spectacle seems almost to have been conceived as a counterpoint to the purges; it reached its apotheosis in 1939 when the leader's sixtieth birthday exhibition was entitled Comrade Stalin and the People of the Country of the Soviets in Visual Art.

The increasingly tense political climate in Europe undoubtedly led the party to look for validation of the present in the past. Aleksandr Nevski, the saviour of Russia from the Teutonic Knights in the thirteenth century, now began to appear in paintings, sculptures and films (Ill. 11), and Ivan the Terrible, another strong leader, was also elevated as the saviour of his people. Such images can be viewed within the context of growing Russian nationalism which was triggered by international political events, but they may also be regarded as spin-offs from the Cult of Personality which Stalin had already built around himself as Supreme Leader.

In his autocratic and cruel style of government, Stalin seems to have had more in common with a medieval Tsar than with the leader of a modern State. As he increasingly concentrated power in his own hands and systematically liquidated all opposition, he was concerned not only to rewrite history to expunge his enemies and make the whole process seem inevitable, but also to provide a tangible legitimacy to his claims. This was based on him being the only heir of Lenin and the rightful guardian and inheritor of the political legacy which had been handed down to him from Marx. As the amount of photographic retouching that was needed to keep in step with disappearances during the Purges increased, photography even started to look like painting. in line with the inverted logic with which Russia was governed at this time, such a bizarre congruence strengthened the claim of painting to be a

conduit of documentary reality.

In achieving the Plans fact, not truth, became a fetish. Fact was truth mediated, and sometimes transformed, by party ideology; as such it became a mystical entity and a driving force in the production of art.

The cult of the dead Lenin preceeded that of Stalin and, during the mid- and late 1920s, was directly encouraged by the artists of *AKhRR* even though such deification had been expressly forbidden by Lenin before his death. Within Russian Orthodox culture there is the belief that the image or icon is the personage or deity it represents and is imbued with all their powers. Before the Revolution the Tsar as well as the Saints had been worshipped in this way and it is hardly surprising that in the atheist Soviet State the impulse for adulation should have been transferred from the spiritual to the political leader. In their turn, the artists made Stalin either into a hero, possessed with super-human powers, or into a saint by adapting the ico-nography of religious art for this purpose (Ill. 12).[25]

Aleksandr Gerasimov became one of the most favoured painters in Stalin's court, depicting him many times and winning one of the first Stalin prizes for his vast painting of the Leader, in military greatcoat, striding with Voroshilov along the battlements of the Kremlin (Ill. 13). Grigori Shegal showed Stalin in more fatherly, less martial, mode as *Leader, Teacher and Friend* (Plate XII), another in the troika of popular images of Stalin painted in the 1930s. In this Stalin is shown as equal with his people, literally he is the same size and on the same level with them, but all are dwarfed by a vast statue of Lenin which looms over-head. Lastly, Vasili Efanov's painting, *An Unforget-table Meeting* (1936-7) showed a more intimate and festive encounter. This took place in the Kremlin between Stalin, Kalinin and other members of the government who met with with the wives of the cap-tains of heavy industry who were attending a confer-ence. But here, as in the previous painting, it is the fiction of Stalin's personal accessibilty combined with his uncontested charisma which is the central subject of the work.

As the history of the Bolshevik Party had be-come an artistic genre in its own right, so now the lives of the leaders, stretching back to infancy, also became a legitimate subject. The boyhoods of Lenin and Stalin were brought alive when, with radiant faces, they received the letter of Marxist ideology just as if the Holy Dove had entered their souls. Like all religions the movement also had its martyrs: Bolsheviks murdered by the Whites or Pavlik Morozov, the boy on the *kolkhoz* who denounced his own father for sabotage and was killed as he tried to protect the harvest.

The Stalin Cult, already strong in the late 1930s, was persued with renewed vigour after the victory and sacrifice of the war. Fyodor Shurpin's *The Morning of Our Motherland* (detail Plate I), one of the most successful examples of this time, shows Stalin in the foreground almost growing out of the earth he had helped to make fertile. His expression is reflective and grave; if he celebrates victory now it is only while meditating on the dark night which lay behind him. In

12

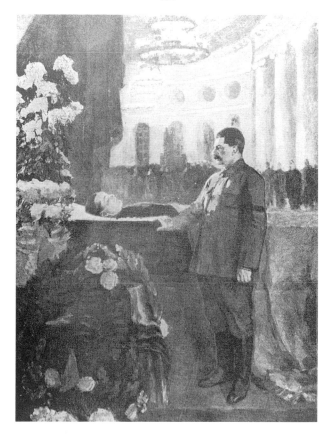

NIKOLAI RUTKOVSKI
Comrade Stalin at the Coffin of S. M. Kirov
Oil on canvas
1937
USSR Ministry of Culture

13

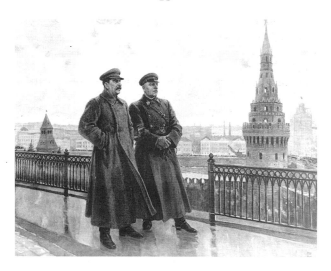

ALEKSANDR GERASIMOV
Stalin and Voroshilov in the Kremlin
Oil on canvas, 300 x 390 cms (118 x 154 ins)
1938
Tretyakov Gallery, Moscow

Plate II

ALEKSANDR LAKTIONOV
Marshal Vasilevski
Oil on canvas, 90 x 70 cms (35 x 28ins)
1947

1949 a large exhibition was organised which celebrated Stalin's seventieth birthday; this was the occasion for a spate of paintings which dealt with episodes in the life of the leader; Vruir Mosesov's *I. V. Stalin Leading a Demonstration in Batumi in 1912* (Plate XVIII) and David Gabitashvili's *The Thirst for Knowledge* (Plate XVII) are examples of this genre.

A pattern for this kind of painting had been laid down in the vast exhibition, conference and publication entitled Thirty Years of Soviet Representational Art which, two years previously, had commemorated the anniversary of the October Revolution. A new classicism which depended upon clarity of line and solidity of volume had become evident, largely in response to the campaign against Impressionism and the painterliness which was associated with it. The prime exponent of this style was Brodski's star pupil, Aleksandr Laktionov (Plate II). Portraiture and sentimentalised genre paintings such as Gugel and Kudrevich's *A Big Surprise* (Plate XXXV) and Boris Lavrenko's *In the Maternity Hospital* (Plate XXXIII) were typical of the new approach. Such an adherence to the intimism of the nineteenth century was also a product of the paranoia of the Cold War and avoided the criticisms of 'Modernism' and 'rootless Cosmopolitanism' which were increasingly being levelled by the Academy of Arts at even such established artists as Aleksandr Deineka and Martiros Saryan.

After Zhdanov died in 1948 Georgi Malenkov became the chief ideologue on cultural matters. At the 19th Party Congress in 1952 he gave a fresh validity to the concept of *tipichnost* as well as a boost to minor genre painting by citing Engels's definition of realism as the 'truthfulness of reproduction of typical characters in typical circumstances.' Some younger artists, such as Gelli Korzhev in *My Neighbour* (Plate VI) or Akhmed Kitaev in *The Fiancée (The Love of my Youth)* (Plate XXXII), felt free to use such ideas as justification for a more satirical view of Soviet society than had perhaps been intended by focussing on contemporary vanity and sexual politics.

In March 1953 Stalin died; the theories of Socialist Realism did not perish with him but as his crimes and personality cult were, in their turn, denounced by the Party, there was much greater latitude for their interpretation. The cultural purges had come to an end and, although it was officially discouraged and victimised by the KGB, a movement of dissident artists was able to gain a foothold outside the Party.[26]

Without an engineer to maintain the system, the aesthetic of Socialist Realism slowly ran out of steam. No longer fuelled by paranoia, terror, enthusiasm or loud applause it became possible for new approaches and ways of working to be accommodated. The framework which Stalin had built could not stand the shock; cynicism and entropy also exacted their toll. Like so much in Brezhnev's Russia, the plant in the art factory was out date and it eventually ceased to function because of its own inbuilt mechanical failure. It had been an Imperial style and, at its height, had been adopted by all the Communist countries of the world. Now it is virtually extinct; the recent demise of State Socialism in Russia guarantees its obsolescence.

Plate III

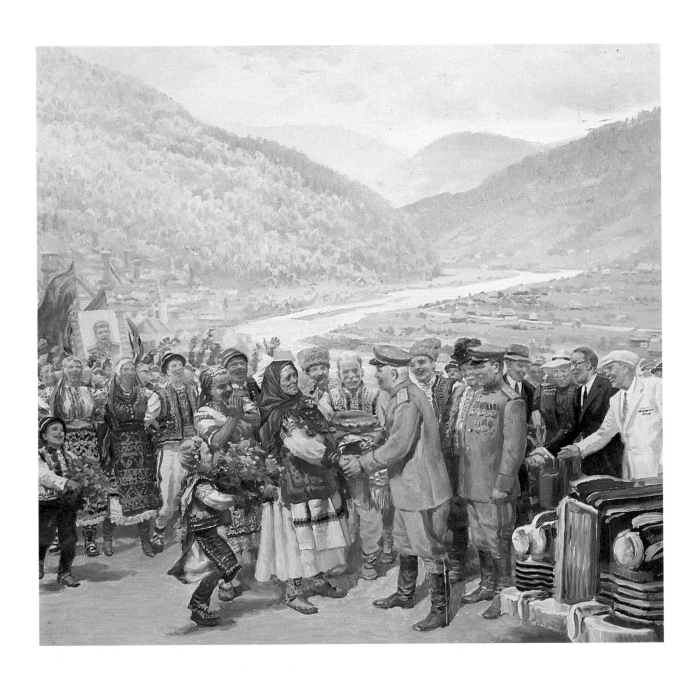

MIKHAIL KHMELKO
Sketch for *The Unification of the Ukrainian Lands in 1939*
Tempera on paper, 46 x 48 cms (18 x 19 ins)
1949

HOW IS THE EMPIRE?

P A I N T I N G I N T H E N O N - R U S S I A N R E P U B L I C S

Matthew Cullerne Bown

Until the recent declarations of independence by many Soviet republics, the USSR comprised more than 20 million square kilometres, of which a quarter were in Europe, the rest in Asia. It was larger than South America and of great ethnic variety. The art of the Soviet Union, encompassing the contributions of myriad nationalities and ethnic groups, presents a unique example of a sustained attempt, mounted by the Communist Party, to weld a single coherent culture out of extreme diversity.

The dimensions of the Soviet Union coincided more or less with those of the Russian empire before 1917. Moscow was the country's cultural centre; and Russian artistic traditions were encouraged and imposed in the non-Russian republics. But the relationship of the non-Russian cultures to the mainstream of Soviet art was always vexed and hedged about with double-talk. The ideologues preached a degree of cultural autonomy; but the practical policies of the Stalin era increasingly contradicted this idea, and by about 1950 the idea of a melding (*sliyanie*) of cultures was being touted by art critics. This signified, in effect, the total subjugation of national traditions to Russian ones. But despite the onslaught from Moscow, national identity survived in the art of non-Russian republics, often in works that, by rendering unto Stalin his ideological due, achieved a striking synthesis between the prescriptive and the personal, the dour and the decorative, the Russian and the home-grown.

The USSR came into being in December 1922 with the unification of four union republics: Russia, the Ukraine, Belorussia and the Transcaucasian republic, comprising Azerbaijan, Armenia and Georgia. This coming-together in 1922, officially described as

voluntary, was actually as a result of the exertions of the Red Army, which put down the independence movements which had flourished across the country during the Soviet civil war of 1918-21. Kiev, for example, had 10 successive regimes before the Bolsheviks seized final power.

During the 1920s and 1930s the Union was reorganised to create a more wieldy administrative structure. Between 1924 and 1936 the new union republics of Uzbekistan, Turkmenia, Tadzhikistan, Kazakhstan and Kirgizia were created in lands abstracted from the Russian republic. Also in 1936, the Transcaucasian Federation was dissolved and the republics of Azerbaijan, Armenia and Georgia created. National feeling was being exploited here; a modicum of self-determination, of specious nationhood, was being offered as a sop for the sake of a greater goal, the stability of the empire.

During the same period, the Soviet Union grew as more and more of the territory of the old Russian empire, given up willy-nilly during the civil war, was won back. The Basmachi revolt in Turkestan was finally extinguished in the late 1920s. The Molotov-Ribbentrop pact allowed the Western Ukraine and Western Belorussia to be annexed in November 1939. In 1940, some Finnish territory was swallowed up; and the deal with the Nazis allowed Stalin to engorge Bessarabia (taken from Rumania), which formed the basis of the new republic of Moldavia; as well as Latvia, Lithuania and Estonia. This completed the re-conquest of lands that had once formed part of the Russian empire. These annexations were, of course, never admitted by the Soviets to be a continuation of Russian imperialism; they were officially described,

until recently, as the outcome of spontaneous popular decisions, and advertised as such in art (Plate III).

This history suggests that, however monolithic the USSR may have seemed from without, the possibility of nationalist uprisings and dissent posed a real threat to its unity. Whatever the official propaganda, politicians in Moscow understood this. No less than political repression and military force, they used cultural policies to bind the country together.

Stalin himself recognised early on that the question of the artistic culture of the non-Russian republics was indissolubly linked with that of their political ties to Moscow; therefore it was understandable that he gave this question special attention. In May 1925, about a year after the death of Lenin, he made a speech entitled 'On the Political Tasks of the University of the Peoples of the East' in which he talked of a 'proletarian culture, socialist in its content' which would 'adopt various forms and means of expression with different peoples'.[1] Proletarian culture, he went on to say, did not replace national culture, but gave it content. In 1930, at the 16th Party Congress, called at the height of the programmes of industrialisation and collectivisation, he returned to this subject. During his main speech he warned of two 'deviations': Great Russian Chauvinism, on the one hand, and nationalism on the other. He quoted Lenin to emphasise the point that, although the abolition of cultural differences was a socialist ideal, these differences would be with them for a long time and would persist even after the world-wide triumph of socialism. He brushed down and refined his formula of 1925: 'What is culture during the dictatorship of the proletariat? It is a culture socialist in its content and national in form, having the aim of educating the masses in the spirit of socialism and internationalism.'[2] During his summing up at the end of the congress he returned to the question again, taking this time the specific example of verbal language. Languages, he said, could not merge and become one until socialism had triumphed not only in the Soviet Union, but around the world. To illustrate what he meant he used an example which suggests that the lost portions of the Russian empire, to be regained only nine or ten years later, were on his mind even then:

There is a Ukraine in the USSR. But there is also a foreign Ukraine. There is a Belorussia in the USSR. But there is also a foreign Belorussia. Do you think that the question of the Ukrainian and Belorussian languages can be solved without taking into account these particular circumstances?[3]

This passage suggests why, in the 1920s and 1930s, the policy of creating new republics was adopted by the political leadership. It not only offered the best chance of political stability and efficient government in a state that was still, for all its bluster, fragile economically and politically; it was also a policy that would seem to legitimise the eventual seizure of new territory by allowing it to be described as an act of reunification. In the face of these considerations, there could be no place in the 1930s for Great Russian Chauvinism; although nationalism, too, continued to be a danger.

Stalin's pronouncements of 1925 and 1930, and in particular his talk of culture 'socialist in its content and national in form', seemed to countenance stylistic variety in the art of the various Soviet republics, as long as these styles could be characterised as springing from national traditions. This induced a degree of sophistry in art discourse, as critics and artists used the national traditions argument to justify work in a whole variety of styles, the inspiration for which, in some cases, was surely European modernism as much as indigenous traditions. This sophistry was the only possible line of defence for those who opposed the vicious attacks on 'formalism' being mounted by the evangelists of realism in Moscow.

In the Ukraine, the most influential painter in the 1920s and early 1930s was Mikhail Boichuk. He led a school of painters and muralists working in a style derived, so his supporters emphasised, from old Ukrainian religious and folk painting (Ill. 14). But Boichuk was a sophisticated man who studied in Cracow, Munich and Vienna and worked in Paris from 1908 to 1911 before returning to the Ukraine. He was known abroad, and received a visit from the Mexican muralist and friend of Picasso, Diego Rivera, in the mid-1920s. He was fully aware of international trends, including the adaptation of various forms of naive and primitive art by the avant-garde; and his work might well be described as an offshoot of the international avant-garde movement. He and his group carried out several big mural compositions in the Ukrainian capital, Kiev. Boichuk himself was a professor at the Kiev Art Institute 1924-36.

The influence of European modernism may also be detected in the work the Armenian, Martiros Saryan, who travelled widely abroad and lived in Paris from 1926 to 1928 before returning to live in the Armenian capital of Erevan. He passed through a symbolist phase in the early 1900s before settling on a colourful language derived from Fauvism, but which his many Soviet supporters in the 1920s and 1930s grandly dubbed 'the realism of the East'. Saryan had a considerable following among the young artists of his republic. His colourful paintings (Ill. 15), like the

14

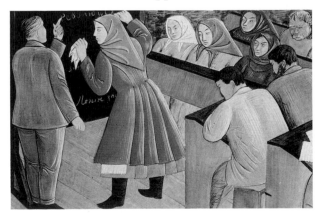

VASILI SEDLYAR
In the School for Liquidating Illiteracy
Tempera
1925
Museum of Ukrainian Art, Kiev

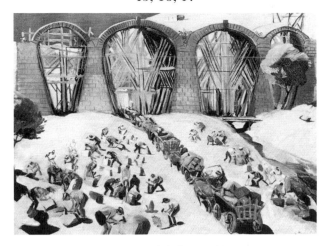

MARTIROS SARYAN
Bridge-Building in Erevan
Oil on canvas, 74 x 92 cms (29 x 36 ins)
1933
Armenian Picture Gallery, Erevan

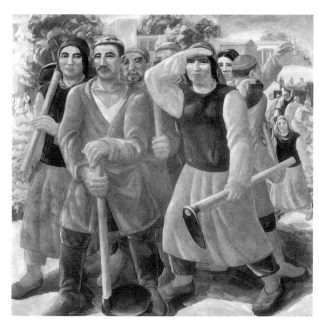

ALEKSANDR VOLKOV
A Brigade Going Out into the Fields
Oil on canvas, 200 x 196 cms (79 x 77 ins)
1933-4
State Museum of the Karakalpak ASSR, Nukus

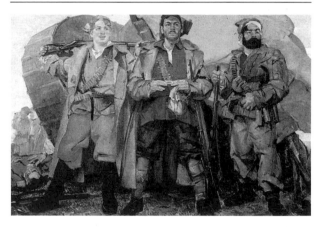

FYODOR KRICHEVSKI
Victors over Wrangel
Oil on canvas, 198 x 322 cms (78 x 127 ins)
1934
Museum of Ukrainian Art, Kiev

work of the Boichukists, make it clear that the stylistic freedoms enjoyed by non-Russian artists was not sustaining any rejection of the socialist content required by Stalin's guiding dictum.

Saturated colour, typical of Saryan's work, was one trait which Soviet critics learnt to expect from painters living in the hot Asian and Transcaucasian republics. Another was a certain simplification or schematisation of form. Again, the proscription against foreign influence meant that this could not be explained in terms of the modernist movement; it had to be presented as something indigenous, springing from national and folk art traditions. Much of the writing published in the 1930s about the work of Aleksandr Volkov, who lived in Tashkent, the capital of Uzbekistan, is an example of such rationalisation. During his studies in St. Petersburg and Kiev in the years 1908-16 Volkov had come into contact with avant-garde art. His work of the 1920s is clearly a variation of Russian cubo-futurism. His work of the 1930s, while more realistic, still betrays this influence in its simplifications of form (Ill. 16). Yet in 1935 Volkov discussed his work as follows:

The painting of the East is built chiefly on the primitive and on a painterly, decorative beginning. This is the basis of my work. Elaborating works of primitive flatness, I have introduced a whole system of triangles and other geometric forms and arrived at the depiction of man based on the triangle, that being the simplest of forms.[4]

In other words, for reasons of political expediency, he described a style that, even in the 1930s, was unmistakeably influenced by cubism and Russian cubo-futurism as springing exclusively from the native traditions of Soviet Asia. This was the kind of gloss needed to ensure the survival of a style nothing like the realism being encouraged in Moscow.

Realism - from 1934 officially termed Socialist Realism - also had its adherents in the non-Russian republics. From the mid-1920s onwards, when filial groups of the Moscow realists' organisation, *AKhRR* (The Association of Artists of Revolutionary Russia), began to be formed all over the USSR, they were an increasingly well-organised and well-supported alternative to artists such as Boichuk, Saryan, Volkov and their followers.

The European republics - the Ukraine, Belorussia - had their own schools of traditional painters, among whom the Ukrainian, Fyodor Krichevski was outstanding. His figurative works of the 1920s were highly stylised and reminiscent of Japanese art; but in the 1930s he joined the movement to a realistic style and in *Victors over Wrangel* (Ill. 17) produced one of the best socialist realist paintings of the decade.

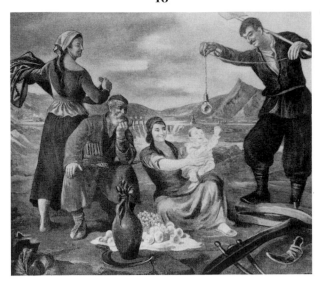

IRAKLI TOIDZE
Ilych's Lightbulb
Oil on canvas
1927
Museum of Eastern Culture, Moscow

Georgia and Armenia, republics with a cultural history bound up with Christianity, also had schools of European-style figurative painters, although these were not particularly strong in the 1920s. The Georgian, Irakli Toidze, produced one of the most engaging propaganda paintings of the 1920s, *Ilych's Lightbulb* (Ill. 18). It shows peasants marvelling at one of the fruits of the electrification of the Soviet Union initiated by Lenin, who advanced the famous slogan 'Communism equals Soviet power plus electrification of the whole country.' In the background is the Zemo-Avchaly hydro-electric power station (*ZAGES*), opened in Georgia in 1927.

In the 1930s a conspicuous school of socialist realists emerged in Georgia. Its members devoted great energy to glorifying their fellow-countryman, Stalin. The source-book for their efforts was Lavrenti Beria's hagiographical booklet, 'A History of the Bolshevik Parties of Trans-Caucasia' (1935). A big exhibition of Georgian art was held in Moscow in 1937 and received with great enthusiasm by the Moscow art establishment. This established a number of Georgian painters as prime movers of the Stalin cult in art. Another painter, Dmitri Nalbandyan, who was born in Georgia of Armenian parents and studied at the Tiflis Academy until 1929, moved to Moscow in 1931 and there pursued the most notorious of all careers devoted to the 'genre of the leader', as he himself liked to put it. In Georgia there was also a Beria-cult of some proportions, the leading exponent of which was Ivan Vepkhvadze.

The leading Armenian realist in the 1930s was Sedrak Arakelyan, who in 1936 produced the charming and revealing *Culture to the Hills* (Ill. 19), showing the accoutrements of (European-style) culture, such as a piano, being carted up into the Armenian mountains for the edification of the peasantry.

Unlike the Ukraine, Belorussia, Georgia and

Armenia, the muslim republics had no tradition of Western-style figurative art. This meant that, before the war, the doctrine of Socialist Realism found scant support indeed in some places. In Kazakhstan, which was only linked to Moscow by train in 1930, a self-taught artist, Ebylkhan Kasteev, struggled alone to adapt his naive folk style, reminiscent of Chinese art, to the demands of Socialist Realism. He produced an oeuvre which never quite loses its naivety but convinces by dint of its intensity (Ill. 20).

The dazzling light and exotic culture of Uzbekistan - and its remoteness from Moscow ideologues - encouraged a number of Russian painters to move there in the 1920s and 1930s. The foundations of a realist school were laid here by Pavel Benkov, a Russian graduate of the St. Petersburg Academy. He and his wife settled in Samarcand in 1930, where they were soon joined by Benkov's former pupil, Zinaida Kovalevskaya. In Samarcand Benkov opened his own art school.

SEDRAK ARAKELYAN
Culture to the Hills
Oil on canvas, 87 x 125 cms (34 x 49 ins)
1936
Armenian Picture Gallery, Erevan

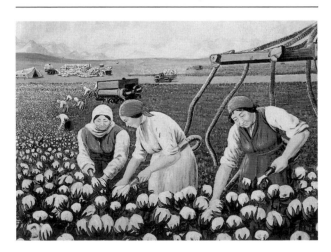

EBYLKHAN KASTEEV
Cotton Picking
Oil on canvas, 93 x 128 cms (37 x 50 ins)
1935
Museum of the Arts of Kazakhstan, Alma Ata

Kirgizia produced one of the most celebrated painters of the Stalin period, Semyon Chuikov. Born in Kirgizia, educated at the Moscow *VKhuTeIn*, he became the first chairman of the Kirgiz artists' union in the 1930s. In Chuikov's work, realism is leavened by a measured simplification of form and intensification of colour; features not pronounced enough to alienate hard-line critics in Moscow but sufficient to make Chuikov an important figure in what might be called the liberal wing of the art establishment of Stalin's time. *On the Kirgizian Frontier* (Plate XI), was his first big official success. Its subject - a Kirgiz border guard and mounted peasant together responding to an incursion into Soviet territory (presumably from China, with which Kirgizia shares a border) - is a typical example of the 'defence theme' which played such an important role in art and literature in the late 1930s; a time when international tensions were running high and the possibility of unprovoked attack was being impressed on the Soviet public.

Although decisions and initiatives originating in Moscow played an increasingly important role in the lives of all artists in during the 1930s, the Soviet Union was such a vast country that the republics most distant from Moscow still retained a degree of cultural autonomy. Not until after the war were the grandiose all-union exhibitions introduced - annual displays of art from all over the country which served to encourage and confirm the ideal of a single, pan-Soviet culture. In the pre-war period, the city to provide the most flourishing alternative to Moscow and Leningrad was, if not Kiev, then Tiflis (in 1936 renamed Tbilisi), the capital of Georgia. Tbilisi was home not only to native artists but also to young Armenians and Azeris who studied at its Academy of Fine Arts.

A number of painters working in Tbilisi not only managed to conserve precious freedoms of style, but also openly rejected the socialist content officially required in the work of all Soviet artists. Two important figures were Lado Gudiashvili and David Kakabadze, both of whom spent the first half of the 1920s in Paris. Gudiashvili painted erotic images of women, drawing on the style of old Iranian art. Kakabadze, on his return from Paris, boldly continued to make abstract paintings. But the outstanding figure, one of the greatest of Soviet painters, was Aleksandr Bazhbeuk-Melikyan, who, although born of Armenian parents, lived all his life in Tbilisi.[5] His invariable subject was the female figure. Many of his paintings are of nudes; others depict exotically-dressed women in the role of juggler, acrobat, or magician. His paintings bear a resemblance to Gudiashvili's insofar as both artists liked to depict voluptuous women; but Bazhbeuk-Melikyan's work is more vital in execution, more intense in its dramas, sexier. His turbulent paint-surfaces flout the official stylistic norms of the 1930s; his subject-matter is devoid of any spirit of social purposefulness. Most strikingly of all, Bazhbeuk-Melikyan completely disregarded the official, puritanical attitude to sex. His oeuvre, along with that of the Leningrad artist, Pavel Filonov, represents the outstanding example of a trenchant personal statement in the art of the Stalin period (Ill. 21).

From the mid-1930s onwards waves of arrests

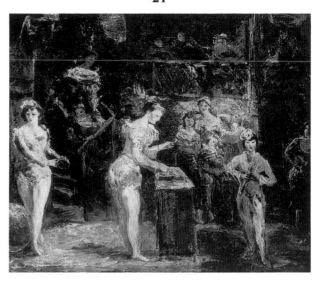

ALEKSANDR BAZHBEUK-MELIKYAN
A Wandering Circus
Oil on canvas, 44 x 51 cms (17 x 20 ins)
1939
Armenian Picture Gallery, Erevan

swept away the intelligentsia of the non-Russian republics as Stalin attempted to destroy what he perceived to be a widespread nationalist threat. Writers suffered much more in these purges than painters, but the latter were also among the victims. The most notorious case was that of the Ukrainian, Mikhail Boichuk, whose mural paintings drawing on folk art sources were now deemed nationalistic. Boichuk and several of his colleagues were arrested and executed; and all the Boichukists' murals were destroyed.

Stalin's chosen antidote to nationalism in the field of culture was an increased emphasis on Russian traditions. This policy only became really evident in the art world after the 1941-5 war; but before the war there were unmistakeable signs of it in other, related areas. An important signifier was the official attitude to the question of language. In 1928, as a means of simplifying and homogenising the mélange of alphabets used by the non-Russian peoples, a whole list of republics were required by decree to adopt a latinised alphabet; the areas affected included Azerbaijan, Georgia, Kirgizia, Uzbekistan, Kazakhstan and Turkmenia. In a series of decisions in the late 1930s, this decree was effectively revoked and the Russian alphabet introduced instead. A decree issued jointly by the Central Committee and the Council of People's Commissars on 13 April 1938, On the Obligatory Teaching of the Russian Language in the Schools of the National Republics and Regions, suggested that a decision had indeed been taken to impose Russian as a *lingua franca* on the whole of the USSR.

The invasion of the Nazis in June 1941 caused great upheavals in the art world.[6] Belorussia and the Ukraine were overrun and many local artists died or were badly wounded in the fighting. As Germany advanced on Moscow and surrounded Leningrad, normal artistic activity came to a halt for some time in Russia, too. Many Russian artists were evacuated to

Plate IV

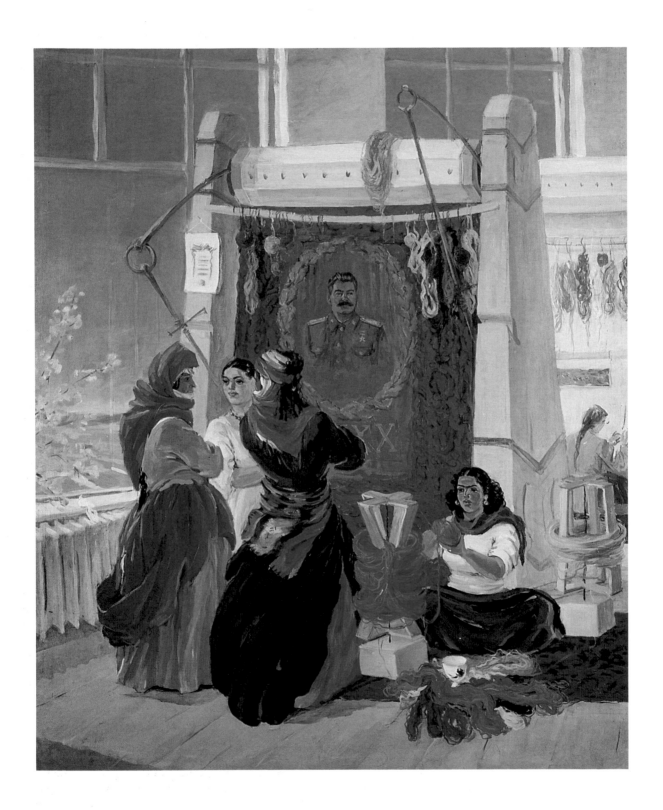

MARIAM ASLAMAZYAN
*Carpet-Weavers of Armenia Weaving a Carpet with a Portrait
of Comrade Stalin*
Oil on canvas, 150 x 124 cms (59 x 49 ins)
1948

Uzbekistan. The staff and students of the art institutes of Moscow, Leningrad and the Ukrainian city of Kharkov were relocated in the ancient city of Samarcand, where students were billeted in the beautiful old Islamic seminary, the Regestan. The first crop of painting students from the Moscow State Art Institute, opened in 1935, completed their diploma works and graduated in Samarcand in 1942. Other Moscow artists lived for a while in the Uzbek capital, Tashkent, where some of them carried out large thematic pictures on war subjects. These artists and students began returning to Russia in 1942 as the tide of battle turned. Their stay seems to have left little mark on the artistic life of the country.[7]

The new emphasis on the supreme importance of Russian cultural traditions was on the agenda in the art world from the moment when, at a banquet in the Kremlin in May 1945, Stalin toasted the Russian people as the nation which had contributed most to victory in the war - a scene recorded in a giant painting by the Ukrainian, Mikhail Khmelko, which was awarded a Stalin prize in 1947 (Plate XIV); but it really only became evident as a fully-fledged policy in the art world a couple of years later.

This was the period of the so-called *zhdanovshchina* - the party's most determined attempt, led by Andrei Zhdanov, to gain control of the country's cultural life. But from the point of view of the non-Russian republics perhaps the most important single event of these years was not any of the decrees on culture issued between 1946 and 1948 but the creation in 1947 of the USSR Academy of Arts. The Academy was designed by the party to promote its policies in the visual arts with greater effectiveness than the semi-democratic artists' unions had done; it was staffed by hand-picked realist artists, nearly all of them Russians. In his inaugural speech the president of the Academy, Aleksandr Gerasimov, made clear the new official line on the nationalities question. He talked of: 'The development and flowering of the multi-national art of the peoples of the USSR, led by the Russian art of the Soviet epoch ...'[8] and urged artists in all the republics to study above all 'the great realist heritage of Russian art'.[9]

This new Russianism conflicted with the policies of the 1920s and 1930s; in particular with the dictum 'socialist in content, national in form', derived from Stalin's own utterances, and with Stalin's explicit warning against Great Russian Chauvinism in culture. This apparent inconsistency could not be overlooked; and it was tackled at some length by the critic, Boris Veimarn, in a speech entitled 'On the Tasks of the Soviet Visual Art of the National Republics' given to the Academy of Arts in 1949. Veimarn made repeated reference to the formula of 'socialist in content, national in form', but now gave it a new gloss. He said that in the duality of form and content, content was 'decisive' (*opredelyayushchee*). He talked of the 'correct understanding of national form in art as a realistic reflection of socialist reality'.[10] Socialist content, he maintained, educated the masses 'in the spirit of internationalism', implying the need for a common formal language across the whole USSR. He tried to discredit the idea that artists in the non-Russian republics should be allowed a certain amount of decora-

tive freedom; drawing a clear distinction between the decorative elements of everyday life and decorativeness as a stylistic device in art, he said:

In some republics of Transaucasia and Central Asia there is a widely-held idea that the national particularity of the Soviet art of the Eastern peoples consists in decorativism. ... But decorativism as a method is formalist and has nothing in common with the tasks of Soviet art. Decorativism does not allow Soviet actuality to be correctly represented in art.[11]

Towards the end of his speech, he summed up succinctly: 'In the light of comrade Zhdanov's directives about the classical heritage, the great importance which the traditions of Russian realism have for for the development of the visual art of all Soviet peoples, without exception, is especially clear.'[12]

In the course of his speech, Veimarn was at great pains to separate out the wheat from the chaff. He reserved special opprobrium for Gudiashvili, who had participated in the great show of the little post-war thaw, the 1946 All-Union Exhibition in Moscow, and whom he now termed a 'recidivist of formalism'. He criticised artists from most of the republics, including the newly-acquired Baltic states. The substance of these criticisms included not only the complaint of decorativism, equivalent to formalism, but also of excessive reliance on historic national styles ('stylisation'); and, as far as content was concerned, of 'mysticism' - implying religious content - and 'idealisation' of historic figures, meaning the failure to portray them from a marxist standpoint.

One artist criticised by Veimarn was an Armenian, Mariam Aslamazyan. Her irreproachable subject-matter did not outweigh, in Veimarn's eyes, the 'decorative tendencies' in her work. *Carpet-Weavers of Armenia Weaving a Carpet with a Portrait of Comrade Stalin* (Plate IV) exemplifies the style of much Armenian painting at this time, and is just the kind of work at which Veimarn's reproaches were directed. It is also a revealing vignette of the role of the folk arts and crafts in the Stalin cult. One can get some understanding of the intimidatory power of public criticism such as Veimarn's from the fact that Aslamazyan's mentor, Saryan, who because of his pre-eminence in Armenia had even been made a member of the country's Supreme Soviet, was so dismayed by the attacks made on him as a 'formalist' in the late 1940s that he cut up his famous *Still-Life with Masks* (1915) into little pieces.

In order to illustrate the kind of distinction that Veimarn was trying to make between what was and was not permissible, Aslamazyan's work may usefully be compared with paintings of the period which received official approval. The outstanding example of an artist who managed to tread the fine line between acknowledging colourful national life and the vice of decorativism, in the form of saturated colour and broad brushwork, was Semyon Chuikov. His picture of a proud Kirgizian schoolgirl making her way across the steppe to school, entitled *A Daughter of Soviet Kirgizia* (Plate XXVI) (executed in two or three versions between 1948 and 1950), was one of a series of paintings extolling life in the little Asian republic that

25

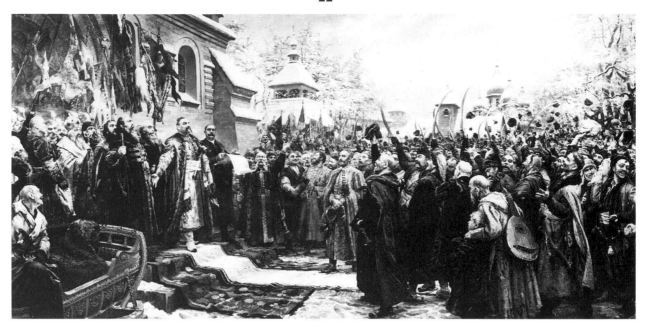

MIKHAIL KHMELKO
Eternal Unity (Eternally with Moscow, Eternally with the Russian People)
Oil on canvas
1951-4

was awarded a Stalin prize in 1949. The viewer would have understood it as a panegyric to the benefits and opportunities brought to a small, unsophisticated country by the Soviet educational system.

Chuikov was an influential artist in the post-war period; his example suggested to painters a way of retaining a modicum of freedom in colour and brushwork at a time when a high academic finish and sombre tonality were at a premium in Moscow. Aleksei Vasilev's *They are Writing about Us in Pravda* (Plate XXVIII) shows the influence of Chuikov in its bright accents of local colour; the red headscarf worn by the girl reading is a direct quotation from *A Daughter of Soviet Kirgizia*. The subject of the painting - a group of Moldavian peasants reading something about themselves in the official party newspaper - emphasises the solicitude of the party for all the national minorities of the USSR.

Vladimir Petrov, a Russian painter trained in Riga and based in Tashkent, produced many canvases which exemplify the approach required of artists in the non-Russian republics. *Akhunova Tursunoi Teaching a Friend* (Plate XXIX) depicts Uzbekistan's first female combine-harvester driver instructing another woman in her esoteric skill. New technology, the emancipation of women, the joy inherent in work on a collective farm and the benefits brought by Soviet power to a once-backward people are all expressed.

A striking painting of this period is *Tomato Picking* (Plate XXVII) by another Russian artist working in Uzbekistan, Zinaida Kovalevskaya. It just about acknowledges Stalinist norms in its technique, although verging on the taboo manner of 'impressionism' condemned by Moscow critics. Insofar as it emphasises the peasant's joy in his work and the abun-

dance of the harvest; and includes, in the figure of the young Russian leaning on a post, a token of the fraternal relationship between the peoples of the USSR; it qualifies as a politicised painting, a work of Socialist Realism. But ideological content was clearly of secondary importance to the artist: she was inspired by the contrast of sundrenched greenery and scarlet tomatoes, by the vivid peasant clothes, and by a sentimental tale of young love.

Tomato Picking probably represents the limits of decorativeness, of painterly freedom and of ideological slackness allowable in a work intended for exhibition in the Zhdanov years. But critics such as Veimarn preferred an altogether less ambiguous, more earnest kind of painting, in which ideological content was apportioned clear pride of place above form. In his speech to the Academy of Arts he made particular mention of Khmelko's *To the Great Russian People* (Plate XIV) which, as he put it, 'expresses the best feelings of the people of the Soviet Ukraine'.[13]

Khmelko, an Ukrainian, was a distinctive figure; probably the most able of all those who attempted vast portentous canvases in the post-war years. He won two Stalin prizes; but even he could run into trouble. Khmelko claims that his painting of Bogdan Khmelnitski (Ill. 22), the Ukrainian chieftain who signed a treaty of friendship with Russia, was refused a Stalin prize because Moscow ideologues saw, in the great mass of figures in traditional Ukrainian costume, the expression of an excess of national feeling.[14]

This picture was one of many commissioned at this time to extol historic links between Russia and the other republics. Some of these works exploited art itself as their subject in an attempt to hammer home the supreme importance of Russian culture. *Makovski*

Giving Advice to Rozentals on his Diploma Work (Ill. 23) was painted by Aleksandr Toropin, who worked in Riga, the Latvian capital. It shows Rozentals, who studied in St. Petersburg at the end of the nineteenth century and is regarded as the founding father of Latvian realism, being taught by a well-known Russian realist.

One idea inherent Toropin's painting was not overlooked by Stalin's art administrators. In order to disseminate the Russian realist tradition more effectively, they established a policy of selecting out the most talented young art students in many of the non-Russian republics and sending them to Moscow or Leningrad to complete their education. Mikhail Abdullaev, an Azeri, is an excellent example of such a Russian-educated painter. He studied first in Baku, then at Moscow's Surikov Institute, and on graduation in 1949 returned to Baku and took up a leading position in the art world of Azerbaijan. When Stalin died, Abdullaev was one of the chosen few summoned to paint him as he lay in state (Plate V).

It was not assumed, however, that student artists from all the republics would move to Moscow or Leningrad for their training. An effective academic education was given in Kiev. Several young Kiev artists, graduates of the Kiev Art Institute, won Stalin prizes in the 1940s and early 1950s; among them Viktor Puzyrkov, a specialist in images of the sea, whose *Stalin on the Cruiser 'Molotov'* achieved a convincing sense of light and air (Plate XV). The diploma work painted by Isaak Tartakovski at the Kiev Art Institute in 1950 was considered so good that it was shown at the 1951 All-Union exhibition in Moscow and illustrated in the catalogue. Tartakovski's strength is in portraiture, illustrated by a painting of the same period of a strapping *KomSoMol* girl, nothing daunted by the prospect of hard unfeminine work (Plate XXXVII). Realism was also taught to a standard sufficient for the Moscow ideologues in the Baltic republics, where a number of Russian painters went to study; and at the Tbilisi Academy, where David Gabitashvili graduated a year before painting his charming work of a poor boy - probably the young Stalin - swotting by lamplight (Plate XVII).

By about 1950 pressure from Moscow had paid off; a homogeneous painting style had been established over the whole country. From Kiev and Minsk to Transcaucasia, from Central Asia to the Baltic republics, works were produced that were indistinguishable in style from those of painters from Moscow and Leningrad. The formula of 'socialist in content, national in form' had had all real meaning drained from it by the analyses of post-war critics such as Veimarn. Indeed, the emphasis on the Russian realist tradition was often evident in more than just painting style. Both the subject and the composition of *A Big Surprise* (*Vrasplokh*) (Plate XXXV), by two Belorussian artists, Adolf Gugel and Raisa Kudrevich, are derived from Ilya Repin's famous picture of a political prisoner's unexpected return, *They Did Not Expect Him.*

Thus by the end of the Stalin period the Party had well-nigh succeeded in imposing a single culture - a single style, a single repertoire of subjects, a single art history - on painters across the whole vast expanse of the USSR. This state of affairs did represent a

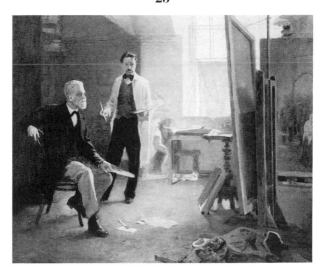

23

ALEKSANDR TOROPIN
Makovski Giving Advice to Rozentals on his Diploma Work
Oil on canvas
1950

triumph of sorts for those many artists, critics and politicians - not all of them Russian - who had striven to achieve it. But the vision of a unified artistic culture began to fade even as it hove into view. Stalin's death in 1953 and the cultural thaw that followed led to developments in the art of the non-Russian republics similar to those which took place in Moscow. One consequence of the new conditions was the destruction of much art that was too-closely identifiable with the worst excesses of the Stalin period. The grandson of the Georgian painter, Ivan Vepkhvadze, has told me how he returned from school one day in 1953 to find his father and grandfather labouring away in a studio awash with the remains of countless drawings and paintings of Lavrenti Beria, all of which they were attempting to destroy after hearing of Beria's disgrace and arrest. More importantly, the heavy dough of prosaic realism was leavened by a return among painters to national and folk traditions and by a fresh look at foreign art. In the Ukraine, Tatyana Yablonskaya, twice a Stalin prize winner, adopted a colourful, simplified style under the influence of Ukrainian folk art. In Moldavia, Mikhail Greku painted his important triptych, *The Story of One Life*, inspired by the design of a hand-made carpet. In the Baltic states artists rediscovered a tradition of *belle peinture* indebted to French art. The 'decorativism' denounced in the late 1940s broke out again all over the place, exemplified in the work of the Azeri painter, Togrul Narimanbekov.

During *perestroika*, young artists have adapted - or simply jettisoned - their art-school training, which is still based on the Russian academic model, in the search for an original style. A synthetic art has appeared in many places, but it is one coloured by national aspirations, a new outlook beyond the boundaries of the USSR, and a spirit of experiment and irreverence, rather than the treacherous old dogma of 'socialist in content, national in form'.

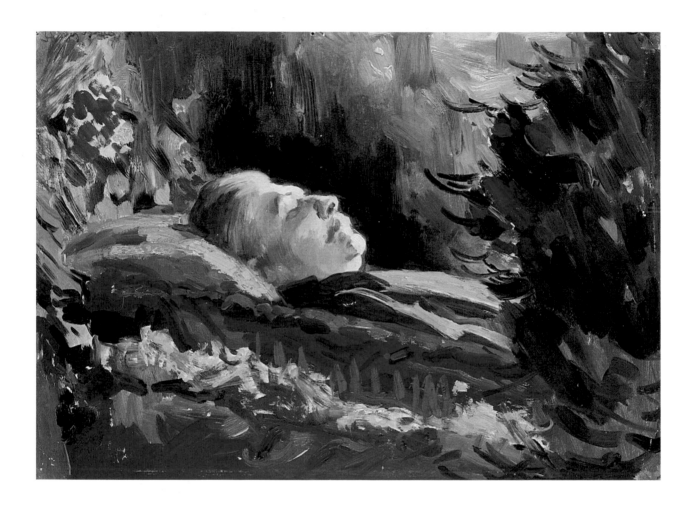

Plate V

MIKAEL ABDULLAEV
Stalin in his Coffin
Oil on board, 25 x 35 cms (10 x 14 ins)
1953

28

ARKADI PLASTOV
Spring
Oil on canvas, 211 x 123 cms (83 x 48 ins)
1954
Tretyakov Gallery, Moscow

THE THAW

PAINTING OF THE KHRUSHCHEV ERA

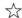

Aleksandr Sidorov

Stalin's death did not give rise to a categorically new style in Soviet art. The octopus of Stalinist ideology survived, still binding the body of art hand and foot. Artists and critics, listening to voices from on high, could catch only echoes of a commotion around the throne, the shuffling or overthrow of certain individuals, such as Beria; but no revision of the teachings of the occupants - and now there were two of them - of the mausoleum on Red Square. This is why the average artist continued as before, hardly aspiring to alter the clichés of subject or style. He or she aimed to create unobjectionable works, capable of slipping through a jury's fine ideological sifting and finding a place at the next thematic exhibition. Such exhibitions remained the chief outlet for a Soviet artist's work for many years after 5 March 1953.

It is revealing to compare the works shown at the great post-war exhibitions of 1957 (celebrating the fortieth anniversary of the revolution) and 1967 (fifteth anniversary), or even at the show entitled Country of the Soviets in 1987, with the Stalinist model provided by the 1939 exhibition, The Industry of Socialism. The *idée fixe* of all these exhibitions was unvarying. They were required to reflect on the one hand the grim past of the peoples of tsarist Russia and their liberation struggle, and on the other the flourishing present: economic and cultural progress, the unwavering growth of the USSR's political and military power, the world-wide struggle for peace. At each of these exhibitions one would encounter a fixed rota of subjects and even the same, recurring titles: *A Soldier of the Revolution, Lenin in Razliv, Lenin in Smolny, Headquarters of the Revolution, Victory Day, Miners' Glory* and so on.

This does not mean, however, that changes could not occur; they did, and Stalin's demise was probably their catalyst. In the 1950s and early 1960s these changes did not deny the nature of the system itself: the role of outright opposition was left to the artistic underground, whose work almost always lay beyond the pale of official exhibitions. But if we fail to pay attention to the first tentative efforts to extricate art from the net of Stalin's and Zhdanov's Socialist Realism, we risk overlooking those events which prepared the ground for the breakthrough into the real artistic freedom which arrived finally in the Gorbachev period. I shall be giving special attention to initiatives and debates originating in Moscow because they set the agenda for change across the USSR as a whole.

The unshackling of Soviet culture after Stalin began in the first half of the 1950s, and certainly before the 20th Party Congress of 1956, when Khrushchev delivered his famous speech denouncing Stalin. Some commentators consider this process of de-Stalinisation in the arts to have started even before Stalin's death.[1] One of its first indicators in the art world was an exhibition of sketches and studies by young Moscow artists which opened in Moscow on 23 January 1954. This show was probably the first significant free exhibition - that is to say, one not vetted by a jury - to be held in the USSR since the 1920s.

The 1954 All-Union exhibition - so-called although it opened in January 1955 - was further evidence of a loosening, slight though it was, of the ideological straight-jacket. This exhibition included works such as Irina Shevandronova's *In the Village Library* (Plate XL) and Konstantin Maksimov's *Sashka the Tractor Driver* (Plate XXXIX), paintings which seemed to suggest that there could be life aside from the

Plate VI

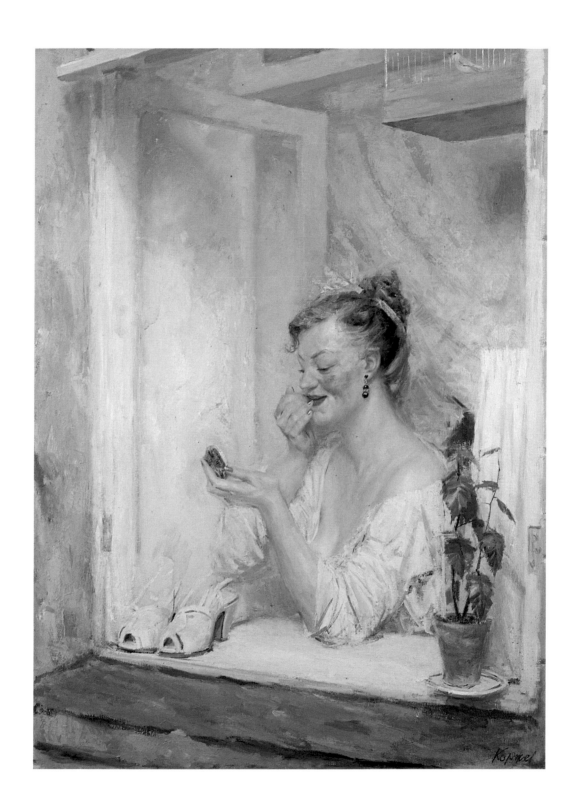

GELLI KORZHEV
My Neighbour
Oil on canvas, 140 x 100 cms (55 x 39 ins)
1954

objectives defined by Stalin's trumpery slogans. A work of great symbolic significance, also shown at this all-union exhibition, was Arkadi Plastov's canvas *Spring* (Ill. 24). It portrays a young woman crouching naked, under a fall of light March snow, in the open yard, where she is dressing her daughter after a bath. This interpretation of a naked figure as a self-sufficient subject, without its being weighted with ideological baggage, such as the theme of Soviet sport or of bathing after the working day, was a new statement in Soviet post-war art. It recalled the Russian Venuses of Kustodiev, the magnificently-built beauties of Konchalovski and other nudes painted in the 1920s - a heritage which had been officially ignored after about 1930. Of course, nudes had been painted without an ideological sub-text by some artists throughout the 1930s and 1940s. Outstanding among these were Aleksandr Bazhbeuk-Melikyan and Lado Gudiashvili; but they were artists working in Tbilisi, an outpost of empire, and marginalised by the establishment. Plastov's *Spring* was significant because it appeared in Moscow and came from the brush of a Stalin prizewinner, an officially-recognised master of pictures glorifying life on the collective farm. *Spring* may be considered the equivalent in painting to Ilya Ehrenburg's novella *The Thaw*, which also appeared in 1954 and was to give its name to the Khrushchev period of relative liberalism in Soviet culture.[2]

Plastov, whose works of the 1950s and 1960s sang not of the feats of toil of the Soviet peasantry but of simple human joys and everyday events, was apportioned a special role - the role of unspoken founder and leader of a new direction in art, the so-called Moscow School of Painting. It is possible to argue that this school is still alive today; certainly it had become, by the 1960s, a broad-based and flourishing phenomenon. In considering the mid-1950s, however, most important is the work of three young artists whose work was of high quality and seems to epitomise the new aspirations of the time. These are Vladimir Stozharov and the Tkachev brothers, Sergei and Aleksei; graduates of Moscow's Surikov Institute, where many of the more important artists of the 1950s and 1960s received a fine academic training (Plate XLVI).[3]

These painters took a fresh look at the tradition of nineteenth-century Russian realism. They rejected an academic finish; they rejected the social tendentiousness of the Itinerants. They drew their inspiration above all from the Union of Russian Artists, a group which flourished at the turn of the century, when it supplanted the Itinerants movement in importance and became a focus for the activity of the best young realist painters in Moscow. The Union aimed at the realisation in art of national, and above all peasant motifs, which they invested with a broad emotional range and executed in a robust painterly style. Like the painters of the Union, Stozharov and the Tkachev brothers wanted to make real and significant to the viewer the venerable, hardy and self-sufficient culture of the Russian peasant. This culture seemed to them a touchstone of spiritual values that had survived the political machinations and opportunism of the preceding decades.

Stozharov painted panoramic landscapes, scenes in country towns and villages, and a famous series of still-lifes depicting traditional Russian food and kitchenware. *The Gingerbread Arcade* (Plate XLII), so-called because it depicts a shopping arcade where stalls were set out and luxury foods such as gingerbread sold, is typical of his work: a portrait of a provincial town that has been left almost untouched by the twentieth century.

The Tkachev brothers chose peasant subjects for their diploma works. Here they could not avoid the blatant evangelising required of art during Stalin's lifetime, but even these student works contain a premonition of later developments. Aleksei Tkachev's *On Holiday* (Plate VII) shows a boy returning home from study at the Suvorov cadet school in Moscow; he walks beside his mother while a young chum tries on his splendid greatcoat. Thus the painting emphasises the important role of the Red Army in the Soviet peasant's life. But it also makes a bold and - for 1951 - novel feature of a wooden cart. The cart, as a metaphor for simple, unspoilt national values, was to run like a *leitmotif* through Russian painting in the 1950s, supplanting and banishing the tractors and combine harvesters of the previous decades. Carts appear *en masse* in Stozharov's *The Gingerbread Arcade*. A cart carrying a wounded soldier is an important motif in *Pushkin's Meeting with Kyukhelbeker* (Plate XLIII), a splendid history painting by another young graduate of the Surikov Institute, Aleksei Merzlyakov. It depicts a well-known event in the life of Russia's national poet; how, dejected and downcast, amid the suffering caused by Napoleon's invasion, he came across a beloved friend. Here again the cart functions as a symbol of nationhood, incorruptibility, courage and resilience.

The Tkachev brothers have created all their major works in harness, as a team of two. The task they set themselves was to understand and live peasant life as their own; they followed Plastov's example and spent (indeed, still spend) many months of the year deep in the Russian countryside, collecting material to be worked up into paintings in their Moscow studio. Some of their images of country life, such as *The Postgirl in Winter* (Plate XLI), are full of simple affection; others are celebratory; yet others mine veins of nostalgia and regret. Their most important works from the period we are considering are *Laundresses* (1957), a work which, by its painterly vigour, helped to push wider the limits of stylistic freedom for Soviet painters; and the dour *Mothers* of 1961.

By the late 1950s there were many artists who subscribed to the principles of the new Moscow School. These included not only young painters such as the Tkachev brothers, Stozharov and Merzlyakov, but members of the older generation such as Konstantin Dorokhov, an artist singled out for criticism in the Zhdanov period. His *September* (Plate XLIV) is clearly a homage to leading painters of the beginning of the century such as Abram Arkhipov and Konstantin Korovin.

The growth of the Moscow School in the 1950s was helped by the failure, or reluctance, of party critics to discern that its notion of the popular, laying more emphasis on a time-honoured way of life than on the communist ideal of a bright future, differed from the class-based analysis required of Socialist Realism. In the end, once more radical artists made their mark in

Plate VII

33

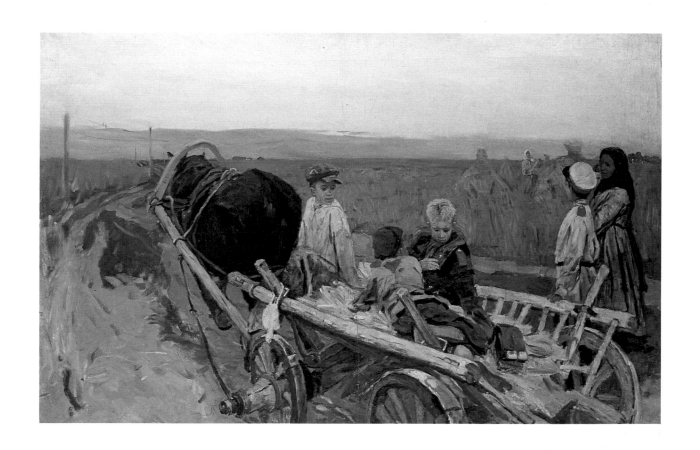

ALEKSEI TKACHEV
Sketch for *On Holiday*
Oil on canvas, 89 x 141 cms (35 x 56 ins)
1950

the early 1960s, the Moscow School's search for truth turned out to be on the sidelines of a much bigger struggle between two ideologies, and their choice of artistic form not sufficiently egregious to seriously distract the Party's cultural bosses.

If a return to robuster artistic values began among artists in the early 1950s as a reaction against the decadence of Stalinist academicism, then the party and government began to reflect this mood from the mid-1950s onwards. Important official events were: the decree of the Central Committee and the USSR Council of Ministers of 4 November 1955, 'On the Elimination of Excesses in Projects and Construction', which put an end to the ornate Stalin style in architecture; the decisions of the 20th Congress of the Party in 1956, and the decree of the Central Committee of 30 June 1956, 'On Overcoming the Cult of Personality and its Consequences'; and a decree of the Central Committee of 28 May 1958 about correcting the mistakes which had been made in the assessment of the activity of certain talented composers - a decree aimed directly at the anti-formalist articles which appeared in *Pravda* in 1936 and at the Zhdanov decrees of 1946-8.

In the art world 1957 was the year of important events. The first All-Union Congress of Artists was held, bringing together representatives of the artists' unions of every republic and resulting in the formation of a USSR Artists' Union.[4] The open letter sent by the artists' congress to the Central Committee spoke of how 'the Party has placed before workers in art the task of achieving the leading place in the world for our literature and art not only according to the richness of its content but also in its artistic power and mastery.' Young artists discovered in these bureaucratic and, at first sight, conventional lines an encouraging attitude being peddled from on high: the suggestion that they were to be allowed greater stylistic freedom. Indeed, some sensed that they were being asked to assume the leading role in contemporary painting practice, to occupy the vacancies which had occurred because of the crumbling of Stalinist norms.[5]

The progressive style that began to appear in Soviet official painting from about 1957 is known as the Severe Style (*Surovyi Stil*), a term coined by the critic Aleksandr Kamenski, who was one of its most vigorous supporters.[6] *Surovyi*, meaning severe, harsh, rigorous, bleak, stern, was an epithet applied contemporaneously by several critics to these paintings. Kamenski has written: 'So, the first and original quality of the Severe Style was a turning to the everyday and a scrupulously exact, deeply faithful representation of it that rejected any kind of tarting-up and pomp. Together with this, the inner basis of the style was a romantic perception of everyday life.'[7] As Kamenski's first sentence suggests, the artists of the Severe Style had much in common with the Moscow School in their rejection of official cliches; indeed, some painters of the 1950s and 1960s could be described as adherents of both the Moscow School and the Severe Style. But as the second sentence suggests, the Severe Style retained something of the old aspirations of socialist realism; the phrase 'romantic perception of everyday life' recalls the 'revolutionary romanticism' to which many Party-oriented painters of the 1920s aspired.

The Severe Style was not a programmatic movement, and so it is not possible to be precise about its membership. Kamenski includes artists such as Gelli Korzhev, Viktor Popkov and Dmitri Zhilinski whom some consider to be essentially independent figures. He excludes others, such as Kirill Mordovin, who seem to me to belong. All in all, it seems best to make the list of practitioners of the Severe Style a comprehensive one (as Moscow artists themselves tend to do) and to view the artists as linked in two ways. First, by a desire for stylistic innovation within the boundaries of Socialist Realism. Second, by a desire to present an unvarnished - although still romantic - image of Soviet life. There is more agreement about the chronology of the style, with Kamenski and others dating it from 1957-1962 - in other words, making it co-extensive with the Khrushchev thaw. However, many stylistic features of the Severe Style were in widespread use throughout the 1960s so this, too, seems like an artificial limitation.

The heroes of the Severe Style paintings were almost always men, usually working men, enduring harsh and trying conditions. This feature characterises nearly all the classic works of the movement: Nikonov's *Our Working Days* (Ill. 25), showing grim-faced construction workers in the Siberian mid-winter, and his frost-bitten *Geologists* (1962); Salakhov's *From the Watch* (1957) and *Repair-Workers* (Ill. 26); the Smolin brothers' *Polar Explorers* (1961); Korzhev's triptych *Communists* (1957-60). The women who appear in Andronov's *Loggers* (1961) and Popkov's *The Builders of Bratsk* (1961) are token figures in a man's world. The exception to this rule is Viktor Ivanov's image of a bleak post-war meal, *A Family in 1945* (Ill. 27).

In their quest for a contemporary style the Severe Style artists looked back to the 1920s, a decade which struck them as less morally and aesthetically debased than their own. This was, of course, the last period when Soviet artists had been able to show the influence of the modernist movement in their work. Deineka's one-man show of 1957 made a great impression on the creators of the Severe Style, for it contained not only post-war works but those created thirty years earlier in the period of struggle between rival artistic groups, when he was one of the leaders of the Society of Easel Painters, *OSt*. Indeed it is the laconic style derived from Deineka and the *OSt* artists by painters such as Nikonov, Salakhov and Pyotr Ossovski (Plate LI), reliant on strong silhouettes and bold simplifications of colour and form, which seems to us the hallmark of the Severe Style.[8] Deineka's famous work of 1926, *The Defence of Petrograd*, became a guiding star for several artists, and the compositions of many works of the late 1950s and early 1960s are based on it. These include Salakhov's *From the Watch*, Nikonov's *Our Working Days*, Popkov's *To Work* and Zhilinski's 17-foot wide *Bridge Builders* (Plate XLVIII).

Indeed, the artists of the Severe Style are among those who must be thanked for the resurrection of much Russian art which had been rejected and condemned under Stalin. They, together with a few critics, collectors and underground artists, began the process of revision which in the 1960s led to the public rehabilitation not only of well-known names such as Altman,

25

PAVEL NIKONOV
Our Working Days
Oil on canvas, 170 x 290 cms (67 x 114 ins)
1960
Kazakhstan Museum of the Arts, Alma Ata

26

TAIR SALAKHOV
Repair Workers
Oil on canvas, 200 x 320 cms (79 x 126 ins)
1960
Art Museum of Azerbaijan, Baku

27

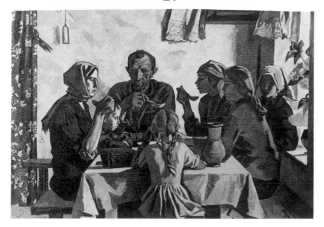

VIKTOR IVANOV
A Family in 1945
Oil on canvas, 175 x 257 cms (69 x 101 ins)
1958-64
Russian Museum, St. Petersburg

Drevin, Lentulov, Chagall, Petrov-Vodkin, Shevchenko, Rodchenko and Falk, but also of whole phenomena, beginning with old Russian icon-painting and ending with the artists' groups of the 1920s.

In their attempts to reflect their epoch in a comtemporary style, young artists sought support not only from past innovators but also from foreign masters. There can be little doubt that Soviet artists at this time dreamed of making some kind of a mark in the world arena, an ambition stimulated by the widening of international contacts in the arts that took place in the late 1950s and early 1960s. The exhibitions accompanying the Sixth World Youth Festival in Moscow in 1957; the exhibition of art from socialist countries in Moscow in 1958, and in the same year the international exhibition in Brussels (at which some Soviet artists received medals); and finally the exhibition of American art in Moscow in 1959, which allowed muscovites to see in the flesh examples of the 'crisis of ugliness' - abstract art: all tended to erode the entrenched cultural isolation of Soviet artists. One particular influence was the Italian Renato Guttuso, who visited Moscow in the late 1950s. His and other visits around this time, such as one by members of the British Kitchen Sink school, whose work also has some affinity with that of the Severe Style artists, suggest that there were some grounds for the internationalist yearnings of Soviet artists in a common mood of post-war disconsolateness experienced by painters across Europe.

In a 5-year period beginning in 1957, 96 official exhibitions of Soviet art were organised in 42 countries, including many Western democracies. A good number of artists spent time abroad. These were not only tried and tested party functionaries and bureaucrats but also some of the most talented artists, such as Pimenov, Plastov, Chuikov, Khandzhyan and Korzhev. But although this was real liberalism in relation to Stalinist norms, we should not overemphasise these new freedoms; there was always a political pay-off. Some artists, such as Konstantin Maksimov, who spent 1955-7 in China as a teacher at the Peking Academy of Arts, were sent to teach the principles of Socialist Realism (Plate LIII). Pyotr Ossovski and Viktor Ivanov, despatched to Cuba in 1962, were required to eulogise that little State upon their return (Plate LI). Those who visited capitalist countries were expected to produce works denigrating the life of their recent hosts. An example of this is Yuri Tulin's painting of an anti-war demonstration in Japan being viciously broken up by the police (Plate LII). The artist, a graduate of the Leningrad Academy, rejoiced in the new stylistic freedoms, but the message of his work aligns it squarely with cold war propaganda.

Thus it would be wrong to overemphasise the extent and robustness of the new artistic freedoms. Not only did that 'truth' sought by the artists of the Severe style - indeed, their whole emancipated view of life - have a political basis in the de-Stalinisation process begun at the 20th Party Congress; but their canvases, however dour in content and flinty in execution, were nonetheless life-affirming and attuned to the heroic in a way which seems to me to link them umbilically to the official utopian outlook. I realise, of course, that this is a harsh judgment of a movement which was an impor-

tant harbinger of today's freedoms.

Khrushchevian utopianism, boosted by achievements such as Gagarin's orbit of the earth - the sort of subject which still merited the full Stalin-style treatment in painting (Plate XLIV) - came to the fore at the extraordinary 21st Party Congress of 1959, designated the Congress of the Builders of Communism. From the high tribune it was announced to the world that as a result of the conclusive triumph of socialism the Soviet country was entering a new period of development, that of the all-out construction of a communist society. Wild predictions were made which foresaw, for example, the unrealisable (and of course unrealised) growth in pay of low-paid workers to 600 roubles per month and of pensions to 400 roubles per month by 1965.

Once one accepts the blood-link of the Severe Style with Khrushchev's programme, then paintings which might at first sight seem surprising, such as Andronov's Lenin (Plate VIII), cease to be paradoxical. Like Gorbachev in the late 1980s, Khrushchev urged a return to 'Leninist' principles as the antidote to Stalinism and Andronov's painting (with what might, admittedly, be a subversive intimation of mortality - a dead leaf on the bench) reflects this. The broad return of the Severe Style artists to 1920s sources may also be understood in these terms: as a return to the Lenin and post-Lenin periods, the time before Stalin really put his mark on Soviet society.

The attempt of the Severe Style artists to reform Socialist Realism was also beset with internal contradictions. These included, for example, that between the defence of the right to a personal assessment of Soviet history and present-day life and the publicist's desire to express truths of broad, popular significance. Problems of style and content are exemplified in Nikonov's important work *Meat* (Plate LIV), a painting which was exhibited in Leningrad in 1961, deemed unacceptable and removed from display by the authorities. If this artist's *Our Working Days* (Ill. 25), painted the previous year, fell within officially-acceptable bounds, then *Meat*, both in its expressionist execution and its grim assessment of life, did not. A work such as *Meat* represented, in 1961, the point of no return for a painter: either he carried on into the artistic wilderness inhabited by the underground, and faced exclusion from exhibitions and harassment by the authorities; or he backtracked a little, imposing a self-censorship not so severe as, but otherwise equivalent to, that practised in the Stalin period.

A number of artists at this time did step across into the comfortless world of non-conformism. Some, such as Vladimir Veisberg, who in the late 1950s and early 1960s shared exhibitions with the Severe Style artists, at first attempted some form of compromise with the authorities. Others made a cleaner break. Erik Bulatov was a star student at the Surikov Institute in the 1950s; his painting *At the Spring* (Plate XLVII) was exhibited at the 1957 World Student Festival. After graduation he retreated from painting into book illustration while preparing the bold leap into abstract painting which he made in the early 1960s. But that would-be radical movement, the Severe Style, tended at best to the refurbishment of the rickety edifice of

Socialist Realism; or perhaps merely to the replacement of a few outdated signs and slogans adorning it, and the construction of a couple of up-to-date extensions. And this under the direct control, no whit weakened, of established party chiefs.

This control at the end of the 1950s and start of the 1960s often assumed the form of apparently unfettered professional discussions in the pages of the journals *Art* (*Iskusstvo*) and *Creativity* (*Tvorchestvo*) about subjects such as real and sham originality, 'contemporary style', Socialist Realism and 'realism without limits', 'creative freedom' and so on. It puts these grandiose subjects in perspective to recall that another topic considered of equal import was a piece of theological hair-splitting: the question of the proper translation of that part of Clara Zetkin's reminiscences of Lenin in which he was reported to have said either that art should be understandable (*ponyatno*) to the people or understood (*ponyato*) by the people.

The seeming ideological neutrality of such discussions was spurious. The innovators in Soviet art could find confirmation of this in the affair of Boris Pasternak's novel, *Doktor Zhivago*, which had been smuggled abroad and was published in exile, as it were, in 1957. The total vilification of the author that was sanctioned from on high in consequence of this, leading to his expulsion from the writers' union and rejection of the 1958 Nobel Prize, as well as the letter of repentance wrung from him and published in *Pravda* on 6 November 1958, in which he avowed that he could only imagine life 'linked with Russia ... with her people, her past, her glorious present and future', served as an unambiguous warning to those who took the thaw for a spring of complete liberation and thought it might be possible to address the viewer or reader directly, without the approval of the political censor.

Five years passed and artists, like writers, were finally compelled to bid farewell to any such illusions they might still have entertained. We come to the historic exhibition of 1962, celebrating the thirtieth anniversary of the Moscow artists' union. It was held in the Central Exhibition Hall, popularly known by its pre-revolutionary name of *Manezh*, stables, for this is where the Tsars' horses were once billeted. Displayed at the *Manezh* show were works from the 1920s by Shterenberg, Falk, Kuznetsov, Drevin and others, hitherto deemed formalist and banished to the reserves of Soviet museums; and also works by Eli Belyutin, Vladimir Yankilevski, Ernst Neizvestny and other present-day 'abstractionists'. The vulgar abuse of these Soviet followers of 'bourgeois modernism' by Khrushchev on 1 December 1962, when he visited the exhibition with members of the party and a number of highly-placed artists[9], signalled the end of the thaw.[10] A new attempt to tighten up the cultural morals of the country was confirmed at a meeting of political leaders with cultural activists on 17 December, and subsequently by another such meeting on 7-8 March 1963 in the Kremlin's Sverdlov hall.[11]

It is a paradox worth noting that the main blows delivered by official ideology in the aftermath of the *Manezh* exhibition fell not so much on 'abstractionists' and underground artists as on the leaders of the Severe Style and their supporters, and especially on the artists

Plate VIII

NIKOLAI ANDRONOV
V. I. Lenin
Oil on canvas, 120 x 161 cms (47 x 63 ins)
1962

Nikonov and Andronov and on the critics Kamenski, Dmitriev and Gastev. Thus speaking at the sixth plenum of the Russian artists' union on 12 April 1963, Vladimir Serov, president of the Academy of Arts and lynch-pin of the conservative offensive, announced: 'It seems to me that, all the same, the main danger is not to be found in abstractionism. It is remote from the aesthetic needs of the people. ... It seems to me, more dangerous are the formalist works which still conserve some image of life but make it ugly and distorted, in which realistic truth is replaced by the ugliness of artificial formal experiments.'[12]

Serov's speech in places recalled Zhdanov:

> Look how our miserable innovators have portrayed our fellow man in recent times. In the works of P. Nikonov, N. Andronov and others ugly, beetle-browed, brutish figures have appeared. And all this has been done ostensibly in a struggle against the varnishing of reality, to show Old Mother Truth unadorned, the grey 'truth' of life. But is this really truth? Is our life really grey, are our people really coarse and primitive? The depiction in such works of man today, of the builders of Communism, whether the authors intended it or not, has proved false and insulting.[13]

Nikonov's 1967 work, *The Headquarters of the Revolution*, was perhaps squeezed out of him in some kind of expiation for past sins. Other artists penned letters of repentance to the newspapers; and expulsions from the artists' union took place. Perhaps the greatest trial for those artists who faced the campaign of public vilification was the ever-present threat of more terrible sanctions, such as arrest and imprisonment or consignment to an asylum.

The invidious situation of artists of the Severe Style may be explained partly by the fact that its basic aesthetic positions were the main topic of the most important critical discussions of the late 1950s and early 1960s; that is to say, those discussions concerning a unified international contemporary style and the related idea of the peaceful co-existence of communist and bourgeois culture; and those concerning the competition of various formal models of Socialist Realism and the broadening of the boundaries and traditions on which it drew. But the main reason for the attention of official critics was, in my opinion, that the experiments of the artists of the Severe Style took place in the genre of the thematic picture, the sacred heart of Socialist Realism. The Severe Style artists were severely hampered by the entrenched protocol of this genre and above all, perhaps, by the expectations and level of aesthetic education of the leadership, which had basically changed little since Stalin's death.

With hindsight it is clear, however, that the little ice-age of 1962-3 did not have a lasting effect. The stylistic freedoms within the boundaries of official art won by the pioneers of the Severe Style were consolidated. Many painters and sculptors in the 1960s took the path of monumentalism, in which the simplification of form typical of the Severe Style was wedded to large scale. Notable among these artists was Mai Dantsig, a Belorussian painter who studied at the Surikov Institute in the 1950s and then returned to live

DMITRI ZHILINSKI
Under the Old Apple Tree
Tempera on panel, 202 x 140 cms (80 x 55 ins)
1969
Russian Museum, St. Petersburg

VIKTOR POPKOV
The Widows: Memories
Oil on canvas, 160 X 224 cms (63 x 88 ins)
1966
Tretyakov Gallery, Moscow

in Minsk. In the 1960s he produced gigantic canvases showing wartime partisans; and in his hands even a potentially lyrical subject, such as the girl hanging out the washing in *A Sunny Day* (Plate LIX), acquired an outsize portentousness. Other artists brought together the formal freedoms won by the Severe Style and the kind of subjects characteristic of the Moscow School and pioneered by the Tkachev brothers and Stozharov in the 1950s. One example is Andrei Tutunov's *The Fisherman and his Son* (Plate LVII), in which a man's back eloquently relates the story of his hard labouring life. One might describe this as a Moscow School painting influenced by the example of the Severe Style. Another such case is the compelling *Logging on the Vetluga* (Plate LVIII) by Eduard Bragovski. In the 1960s Bragovski fashioned a decorative style that has had many imitators; his landscapes were an influence on such an independent figure as Viktor Popkov; and today one can even assert the existence of a school of Bragovski in Moscow. *Logging on the Vetluga* may lie chronologically outside the period of the Severe Style as Kamenski and others would like to define it, but it clearly derives much from the movement both in content and execution.

In the 1960s a small number of highly individual artists found their voice within the official structures of the artists' union, official commissions, all-union exhibitions and so on. Dmitri Zhilinski developed a style of tempera painting based on the example of the early Renaissance masters and old Russian religious painting, using as his subjects family and friends (Ill. 28). His ascetic style and introverted subject-matter were widely adopted by the next generation of Moscow artists; partly, perhaps, because of Zhilinski's own influential position as a teacher at the Surikov Institute. In Viktor Popkov's oeuvre, works of disarming candour and frank sentimentality, such as *A Family in July* (Plate LV), alternate with paintings which induce anxiety and doubt about the possibility of achieving a harmonious world and suggest the fragility and defencelessness of all human ideals. His series of paintings devoted to the old peasant women of the Mezen region, widows bereaved by the war, strikes an unique elegiac chord in Soviet art of the 1960s (Ill. 29). Like Zhilinski, Popkov often used tempera, although with strikingly different results, and produced many innovative compositions.

We should mention here Ilya Glazunov, who contrived to have a one-person exhibition at the Manezh in 1964 without treading anything like the official path for successful artists. Objectively considered, Glazunov, despite his popularity, is a weak painter, and much more successful as an illustrator. The originality of his contribution to the art, or more accurately to the social culture, of the 1960s lay in his ability to find - or create - his own viewers, patrons and buyers. And this was not an elite audience, but an extremely wide one, from the dissident intelligentsia to members of the politburo, from pensioners to millionaires, including foreign ones.

In many ways, however, the towering figure in what might be called the public painting (to distinguish it from the private activity of the underground) of the 1960s was Gelli Korzhev. His distinctive creative personality, apparent already in his early works, does not allow us definitively to situate him in any school, although I have already mentioned his triptych, *Communists*, in our discussion of the Severe Style. Kamenski remembers his *In the Days of War* (1954) as one of those works of the early 1950s which created a 'change of the structure of intonation'[14] in the Soviet art of the post-Stalin days. It depicts a painter draped in a military great-coat sitting before a blank canvas, about to embark on a painting. Kamenski notes that the critics of the time were amazed by the absence of action in the painting at a time when story-telling was everything; he himself notes the 'diary-like honesty and faithfulness' of the depiction of the artist in his shabby studio. This is all true enough, but one wonders how Kamenski and others would have reacted to the picture had it been left in its original form, in which the artist sat not before a blank canvas but one bearing an image of Stalin.[15]

Korzhev's works of the mid-1950s follow an unusual seam in the genre painting of the time, ranging from the satire - not without a streak of cruelty - of *My Neighbour* (Plate VI) to dispiriting scenes of everyday life: a young couple breaking up; a man abandoned by his family; a middle-aged supplicant's forlorn vigil in an official waiting room.

In essence, each of the artist's succeeding pictures, most notably those from the series Scorched by the Flames of War (Ill. 30), compelled official critics to reevaluate his work, to find new arguments that would justify the inclusion of this master in the line of development of socialist realism. Korzhev's formal innovations of the 1960s are apparent in *Anxiety* (Plate LVI), a work meant for inclusion in the series Scorched by the Flames of War but subsequently excluded from it. These are the cinematic features of expanded scale and

30

GELLI KORZHEV
Mother
Oil on canvas, 200 x 200 cms (79 x 79 ins)
1962-7
Russian Museum, St. Petersburg

dramatic cropping; a compressed pictorial space, like that of a classical bas-relief; and a highly-wrought paint surface which conveys an indefinable sense of tragedy, like flayed elephant hide. But the great challenge levelled at official dogma by Korzhev's paintings arose from their analysis of the situation of the individual. He spoke, crucially, of men and women not simply as heroes but also as the victims of historic events such as the war. Moreover, the suffering of his protagonists is not portrayed as a discrete event, quickly over and done with, but as an abiding wound to the body or the mind, a never-ending ache. Korzhev was perhaps the first to occupy the kind of professional position that in some ways changed the relationship between the artist and the state patron. Many artists had adapted their individuality to the needs of official culture, but official culture and ideology were also compelled now to adjust to the revelations of a master it had recognised and continued to need.

That little peninsulars of respect were conquered and held by the outstanding artists of the 1960s such as Korzhev, Zhilinski and Popkov did not seriously alter the lot of Soviet artists as a whole. Those, traditionalists and innovators both, who addressed themselves to the Soviet public, were doomed, despite their boldest utterances, to remain in the clutches of official culture. They had to participate in its parades of achievements in the form of thematic exhibitions; to rely on the receipt of state commissions, studios and awards; to wait on the outcome of party conferences and congresses; to discuss and approve official decrees; and to judge and condemn those colleagues who had succumbed to the influence of bourgeois culture. In the frequent struggles of the so-called 'progressive' wing of the artists' union with the Academy of Arts, of liberal critics with conservatives, of young artists with those remaining representatives of Stalinist Socialist Realism such as Nalbandyan and Serov, the conservatives nearly always had the last word, right up until the period of *perestroika*. For this was a struggle conducted within, and for the preservation of, a system of official culture controlled from above. Those artists who did not link their work with the dominant ideology were compelled to disappear from the arena of Soviet artistic life, to go underground or emigrate, or else to feel the full force of moral and administrative pressure from the authorities.

However, it is probably true to say that, although the official structures remained in place, the whole notion of Socialist Realism had been seriously undermined by the end of the 1960s. The rehabilitation of artists and movements from the past had compelled it to digest a whole host of unexpected guests and previously unknown precursors and forbears, so that it found its once monolithic organism distended from within to the point of bursting. Moreover, many of the next generation of artists, the so-called *semidesyatniki* or seventies generation, virtually abandoned it. They no doubt drew conclusions from the experience of their predecessors. The most important of these was to realise the virtual impossibility - despite Korzhev's example - of conserving the creative individuality and independence of an artist if he was intent on recasting the face of Socialist Realism. The other, equally important conclusion, drawn from the example of Zhilinski and Popkov, was that, before ascending the high tribune of public pronouncements and broadcasting on behalf of one's era, it was necessary to understand and explain the sense of one's own existence and the proper task of one's own art, independent of topics of the day, the struggle of political passions and the myths of historical progress.

Plate IX

GEORGI RUBLYOV
A Factory Party Meeting
Tempera on canvas, 160 x 200 cms (63 x 78 ins)
1932

Plate X

EKATERINA ZERNOVA
Tank-Driver Kuznetsov
Oil on canvas, 120 x 89 cms (47 x 35 ins)
1933

Plate XI

SEMYON CHUIKOV
Sketch for *On the Kirgizian Frontier*
Oil on canvas, 63 x 72 cms (25 x 28 ins)
1938

Plate XII

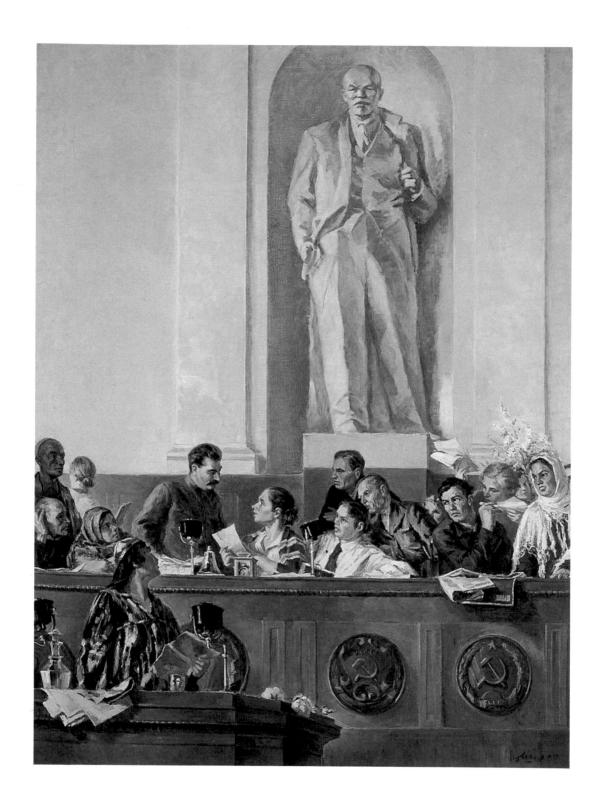

GRIGORI SHEGAL
Leader, Teacher and Friend
Oil on canvas, 120 x 90 cms (47 x 35 ins)
1937

Plate XIII

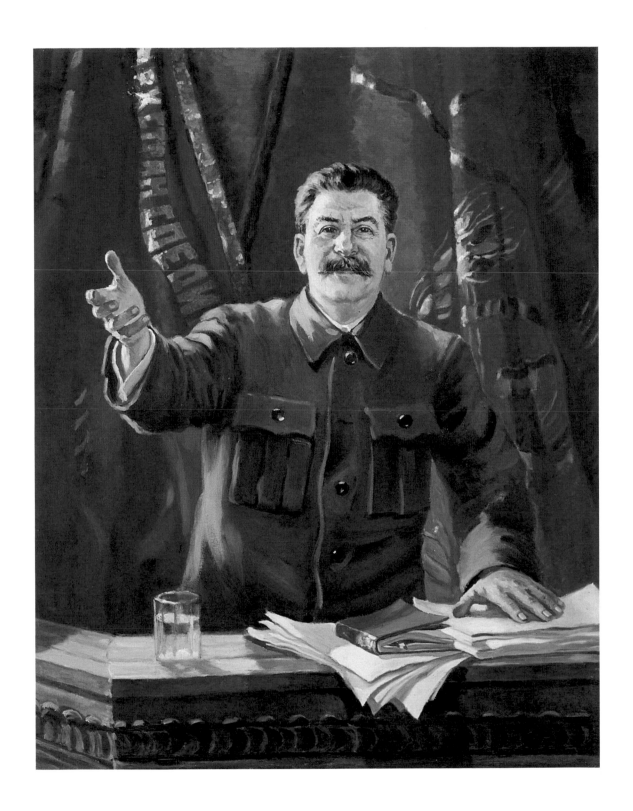

ALEKSANDR GERASIMOV
Stalin at the 18th Party Congress
Oil on canvas, 121 x 96 cms (47 x 38 ins)
1939

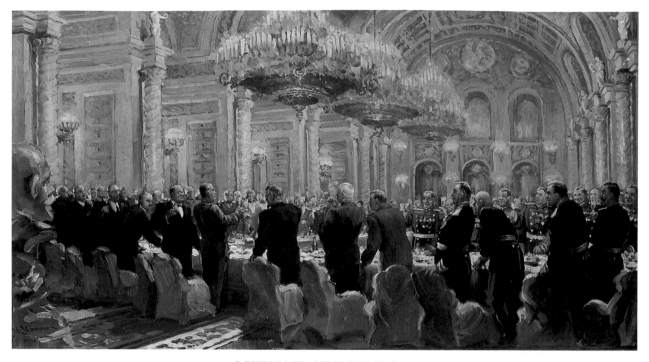

MIKHAIL KHMELKO
Sketch for *To the Great Russian People*
Oil on paper, 40 x 72 cms (16 x 28 ins)
1946

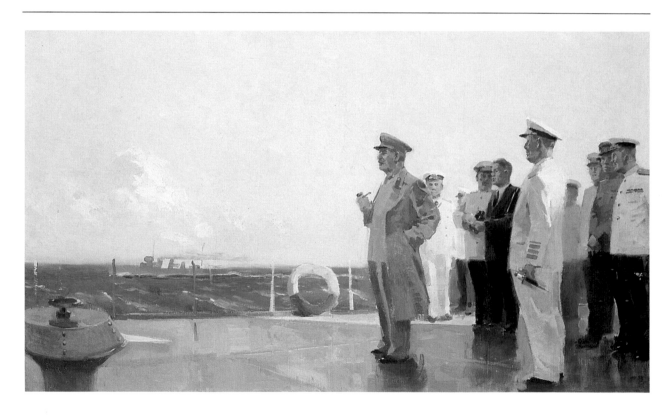

VIKTOR PUZYRKOV
Sketch for *Stalin on the Cruiser 'Molotov'*
Oil on canvas, 59 x 100 cms (23 x 39 ins)
1949

Plate XVI

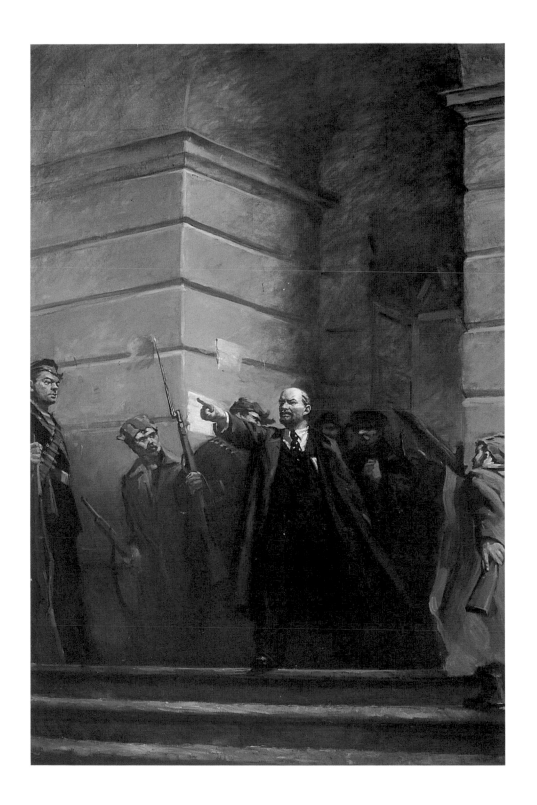

VIKTOR TSYPLAKOV
Lenin in Smolny
Oil on canvas, 300 x 220 cms (118 x 87 ins)
1947 (recreated by the artist in 1988)

47

Plate XVII

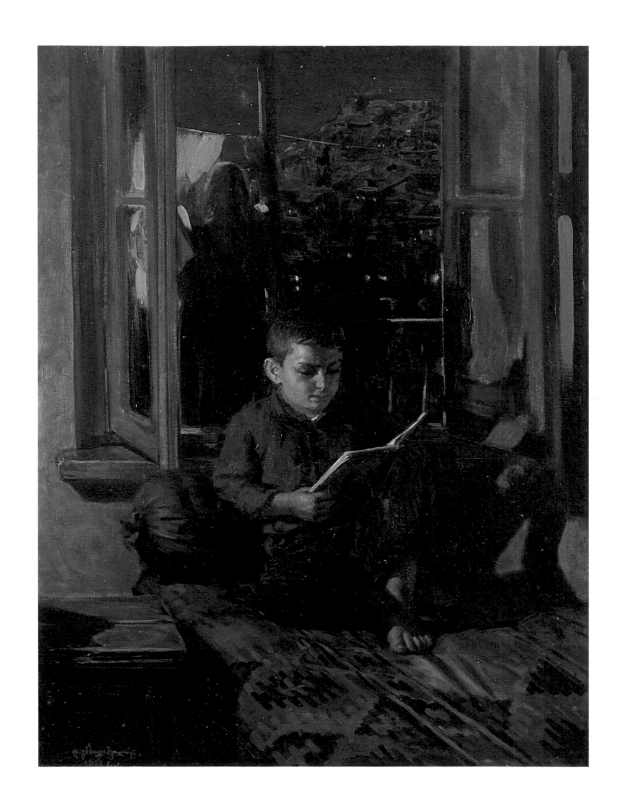

DAVID GABITASHVILI
The Thirst for Knowledge
Oil on canvas, 110 x 85 cms (43 x 33 ins)
1953

Plate XVIII

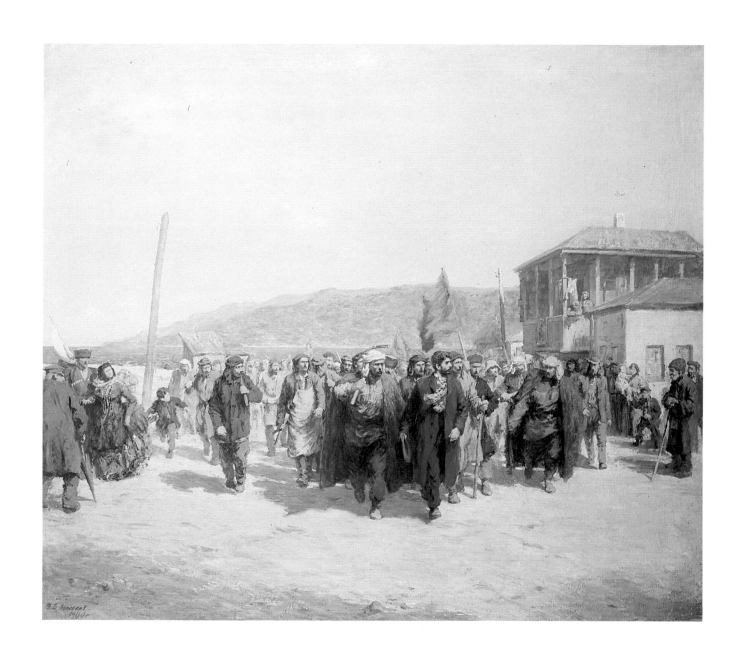

VRUIR MOSESOV
I. V. Stalin Leading a Demonstration in Batumi in 1912
Oil on canvas, 131 x 151 cms (51 x 59 ins)
1949

Plate XIX

MIKHAIL KOSTIN
In the Stalin Factory
Oil on canvas, 133 x 173 cms (52 x 68 ins)
1949

Plate XX

ANATOLI NIKICH
Still-Life with the Medals of M. Isaakova
Oil on canvas, 147 x 164 cms (58 x 65 ins)
1951

Plate XXI

BORIS IORDANSKI *and* **GEORGI RUBLYOV**
Glory to Stalin (design for a ceiling painting)
Tempera on canvas, 165 x 95 cms (65 x 37 ins)
1951

Plate XXII

FRANTS ZABOROVSKI
The Port of Astrakhan (sketch for a mural)
Oil on canvas, 38 x 165 cms (15 x 65 ins)
1950

Plate XXIII

FRANTS ZABOROVSKI
A Construction Site in Astrakhan (sketch for a mural)
Oil on canvas, 38 x 165 cms (15 x 65 ins)
1950

Plate XXIV

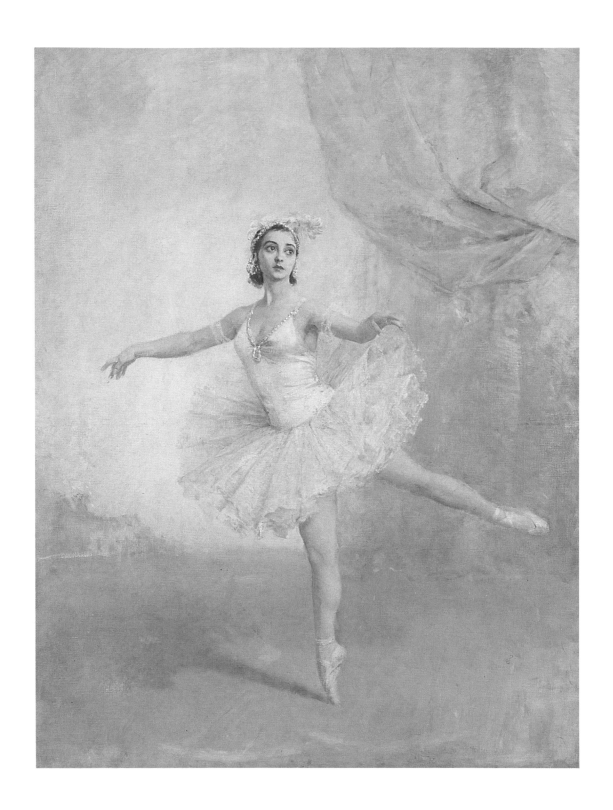

VLADIMIR SEROV
Portrait of Krasnosheeva, a Dancer with the Kirov Ballet
Tempera on canvas, 180 x 135 cms (71 x 53 ins)
1948

Plate XXV

55

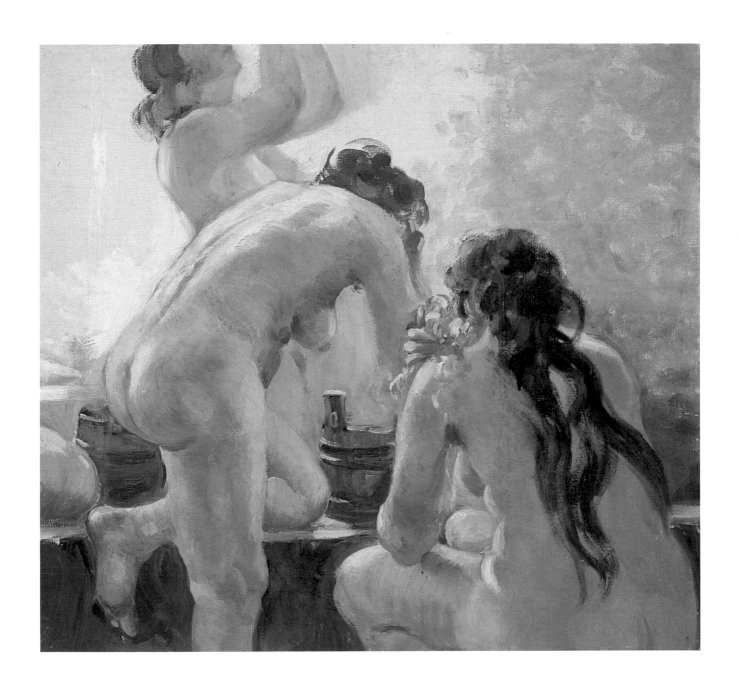

ALEKSANDR GERASIMOV
Study for *A Russian Communal Bath*
Oil on canvas, 80 x 87 cms (31 x 34 ins)
1946

Plate XXVI

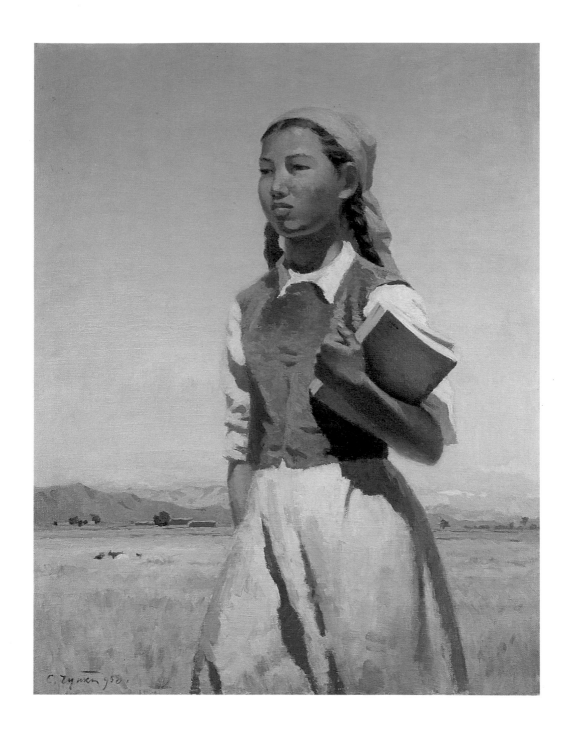

SEMYON CHUIKOV
A Daughter of Soviet Kirgizia
Oil on canvas, 120 x 95 cms (47 x 37 ins)
1950

Plate XXVII

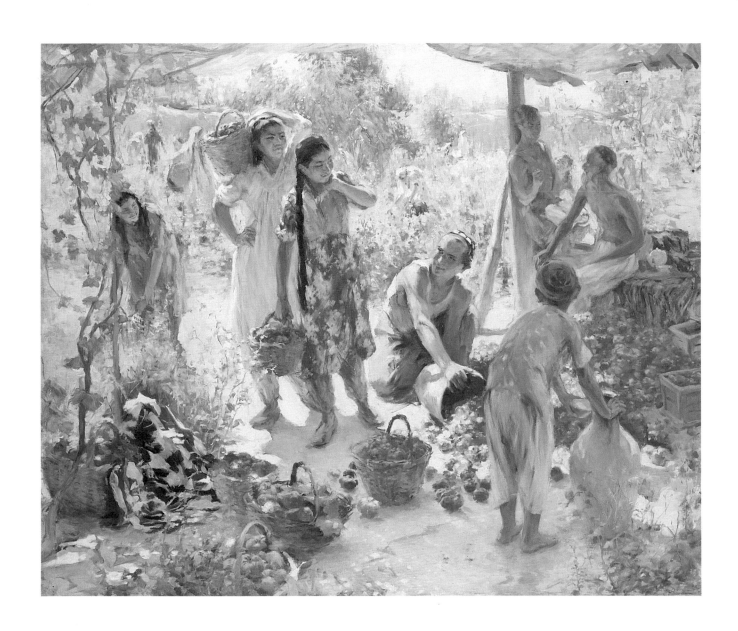

ZINAIDA KOVALEVSKAYA
Tomato Picking
Oil on canvas, 150 x 180 cms (59 x 71 ins)
1949

Plate XXVIII

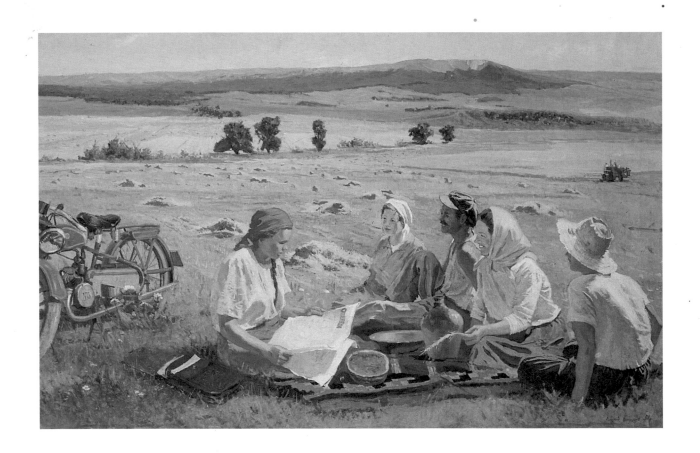

ALEKSEI VASILEV
They are Writing about Us in Pravda
Oil on canvas, 99 x 156 cms (39 x 61ins)
1951

Plate XXIX

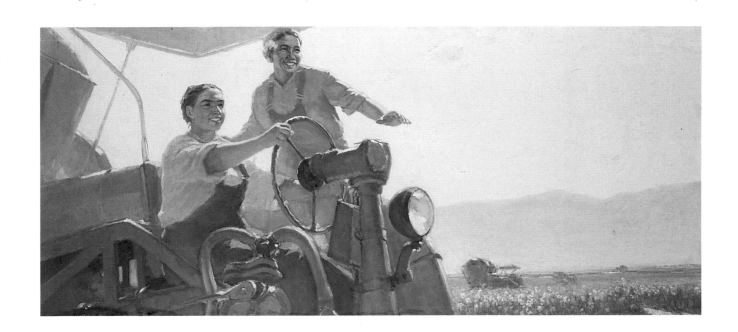

VLADIMIR PETROV
Akhunova Tursunoi Teaching a Friend
Oil on canvas, 89 x 200 cms (35 x 79 ins)
1954

Plate XXX

ANTONINA SOFRONOVA
In a Country Garden
Oil on canvas, 66 x 55 cms (26 x 22 ins)
1950

Plate XXXI

SERGEI GERASIMOV
Evening
Oil on canvas, 80 x 100 cms (31 x 39 ins)
1950

Plate XXXII

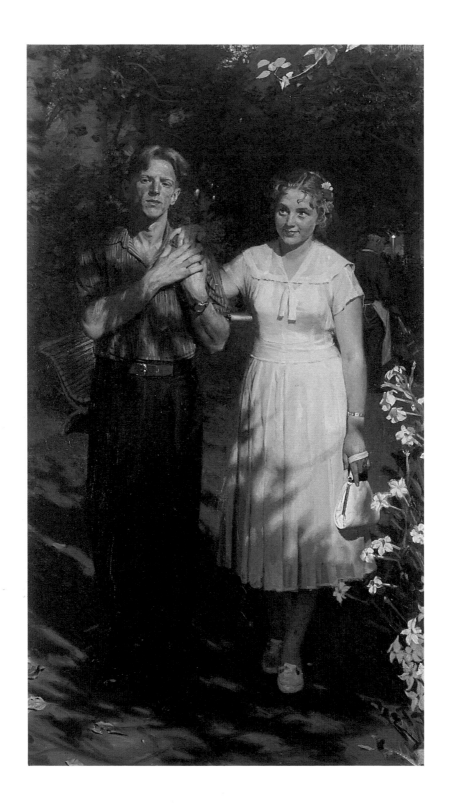

AKHMED KITAEV
The Fiancée (The Love of my Youth)
Oil on canvas, 200 x 112 cms (79 x 44 ins)
1953-5

Plate XXXIII

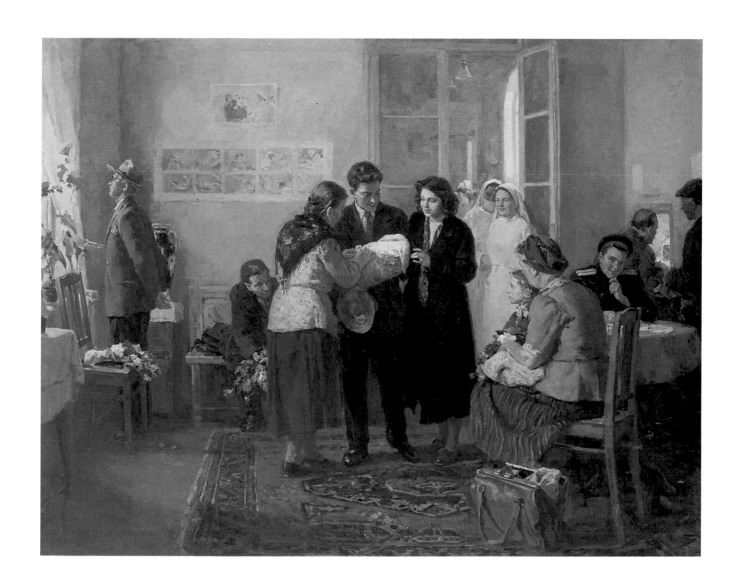

BORIS LAVRENKO
In the Maternity Home
Oil on canvas, 121 x 155 cms (48 x 61 ins)
1954

Plate XXXIV

NIKOLAI BASKAKOV
A Poor Catch
Oil on canvas, 100 x 141 cms (39 x 56 ins)
1952-4

Plate XXXV

ADOLF GUGEL *and* **RAISA KUDREVICH**
A Big Surprise
Oil on canvas, 120 x 133 cms (47 x 52 ins)
1951

Plate XXXVI

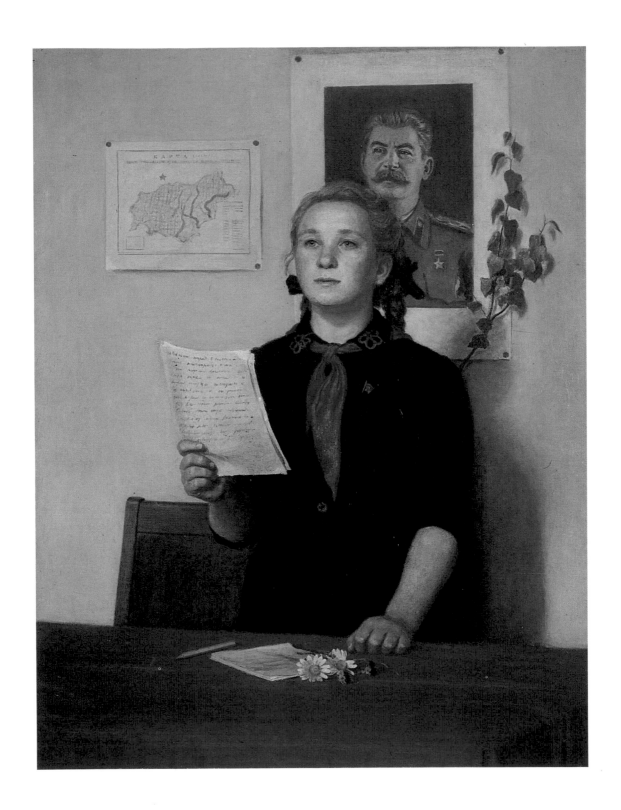

VYACHESLAV MARIUPOLSKI
A Leader in the Pioneers
Oil on canvas, 92 x 71 cms (36 x 28 ins)
1949

66

Plate XXXVII

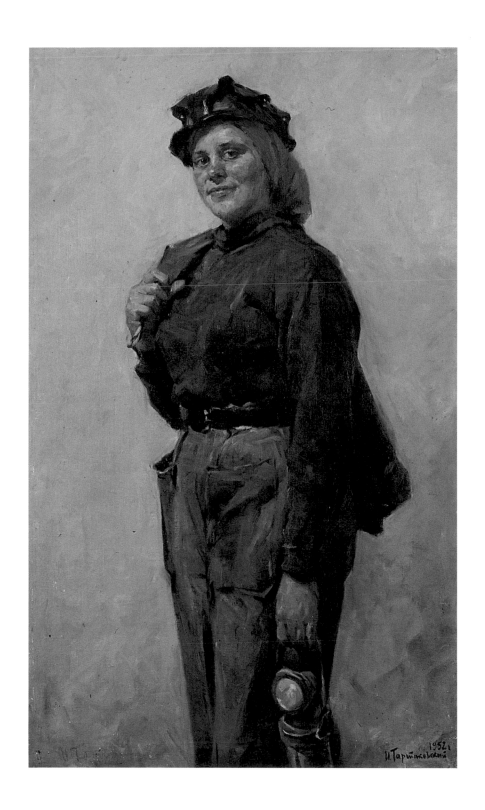

ISAAK TARTAKOVSKI
Answering the KomSoMol's Call (Reconstruction in the Donbass)
Oil on canvas, 140 x 85 cms (55 x 33 ins)
1952

Plate XXXVIII

YURI PODLYASKI

Mariya Semenovna Semenova, from Zagorsk, a Collective-Farm Team Leader

Oil on canvas, 76 x 54 cms (30 x 21 ins)

1950

Plate XXXIX

KONSTANTIN MAKSIMOV
Study for *Sashka the Tractor Driver*
Oil on canvas, 40 x 30 cms (16 x 12 ins)
1954

Plate XL

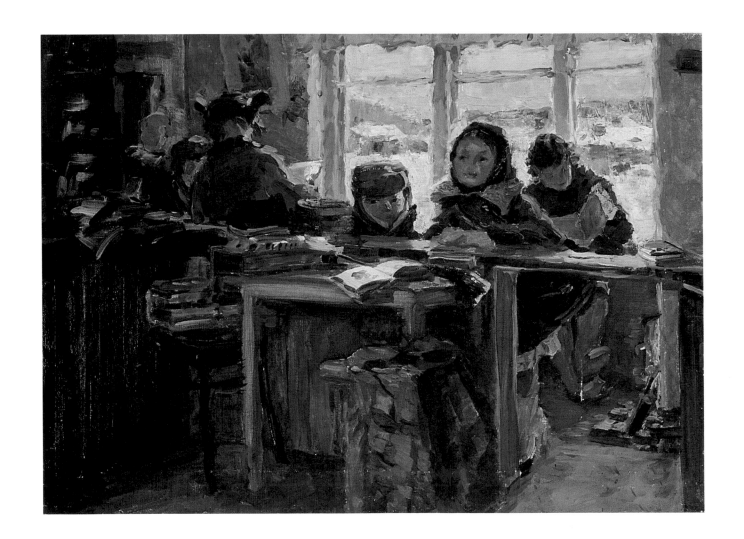

IRINA SHEVANDRONOVA
Sketch for *In the Village Library*
Oil on canvas, 31 x 43 cms (12 x 17 ins)
1954

Plate XLI

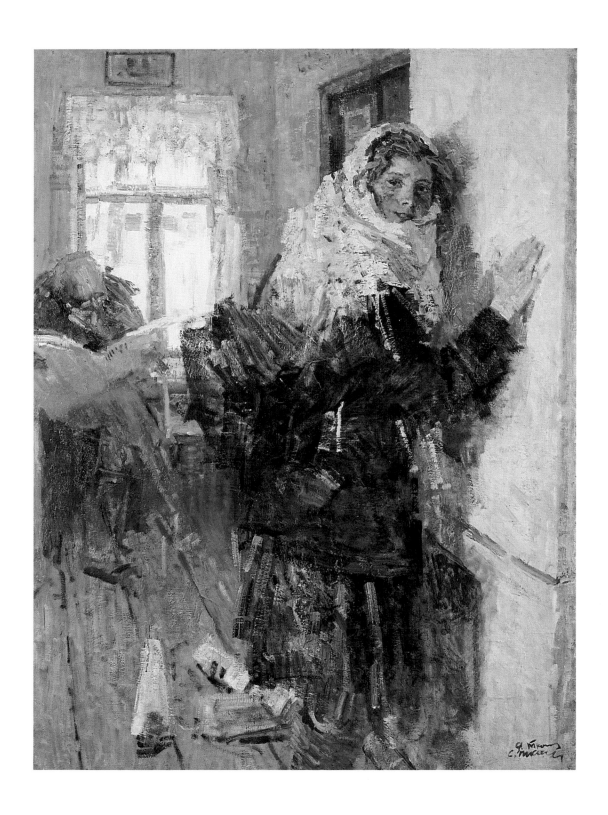

ALEKSEI *and* **SERGEI TKACHEV**
The Postgirl in Winter
Oil on canvas, 127 x 96 cms (50 x 38 ins)
1951

Plate XLII

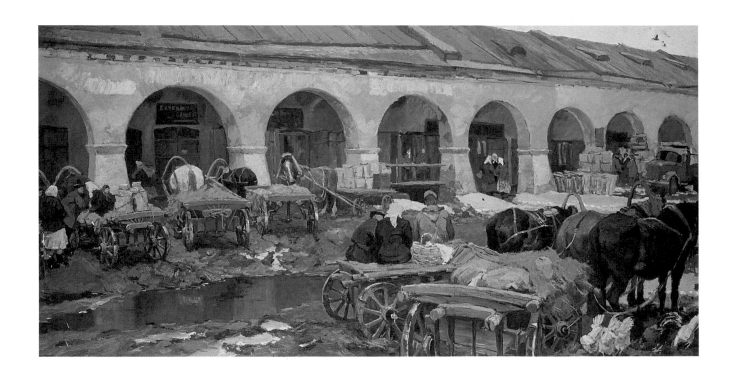

VLADIMIR STOZHAROV
The Gingerbread Arcade
Oil on canvas, 105 x 212 cms (41 x 83 ins)
1956

Plate XLIII

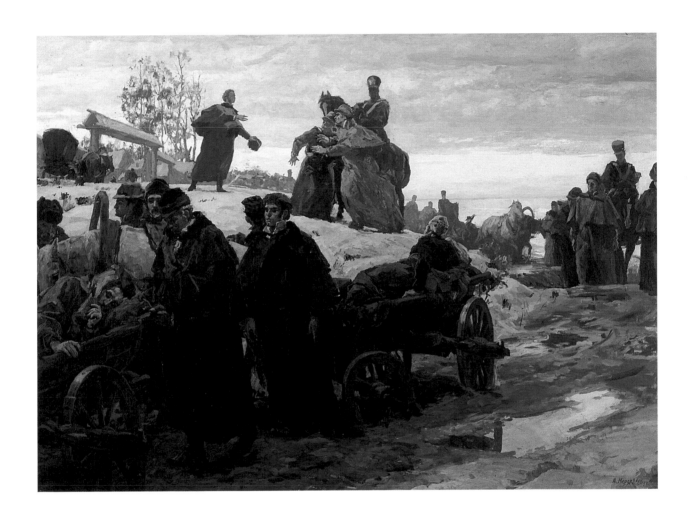

ALEKSEI MERZLYAKOV
Pushkin's Meeting with Kyukhelbeker
Oil on canvas, 146 x 201 cms (57 x 79 ins)
1957

Plate XLIV

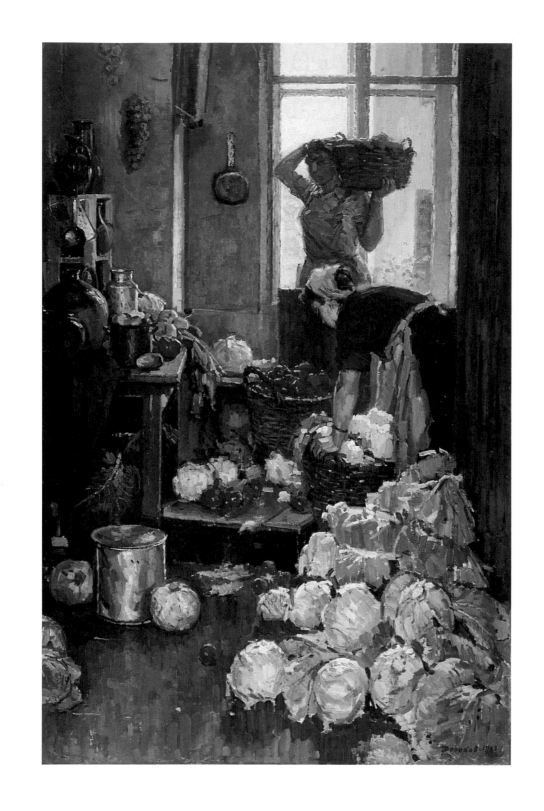

KONSTANTIN DOROKHOV
September
Oil on canvas, 201 x 130 cms (79 x 51 ins)
1957

Plate XLV

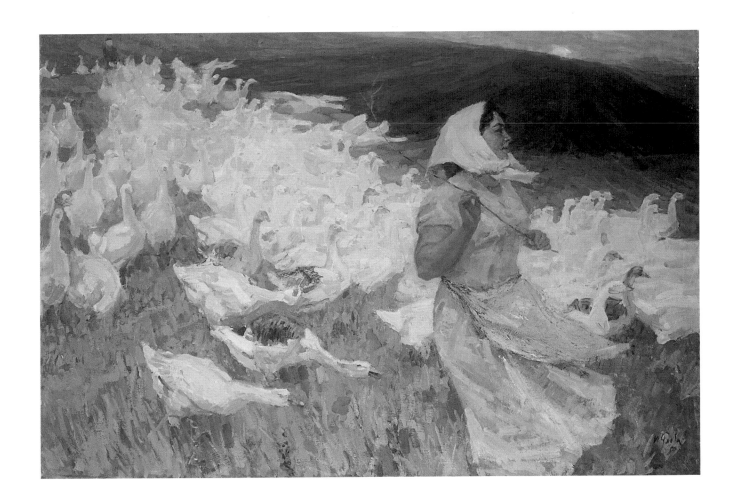

PAVEL GLOBA
Galya of the Birds
Oil on canvas, 136 x 201 cms (54 x 79 ins)
1957

Plate XLVI

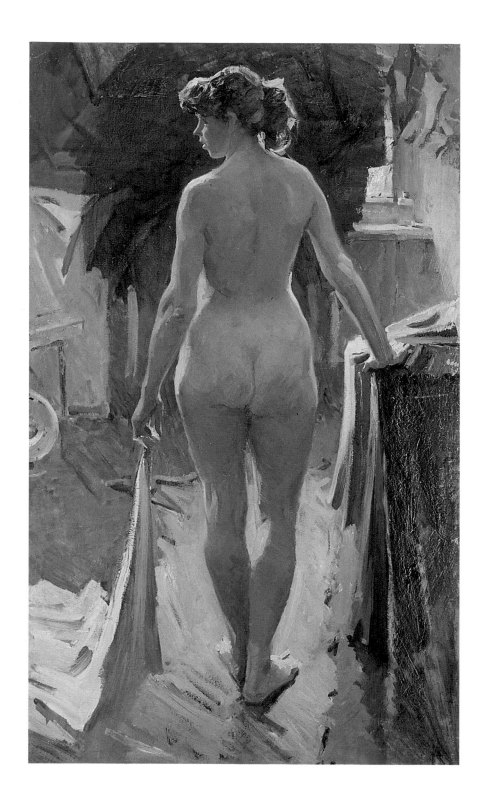

MAI DANTSIG
Nude
Oil on canvas, 150 x 90 cms (59 x 35 ins)
1957

Plate XLVII

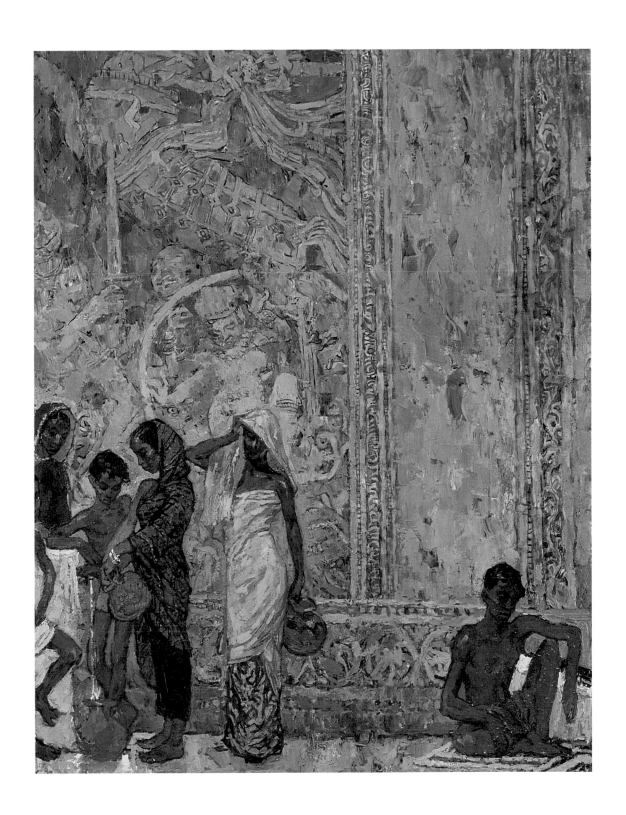

ERIK BULATOV
At the Spring
Oil on canvas, 128 x 100 cms (50 x 39 ins)
1957

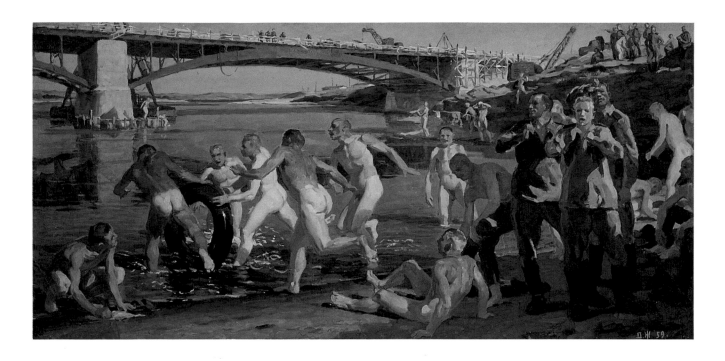

DMITRI ZHILINSKI
Sketch for *The Bridge Builders*
Oil on paper, 42 x 87 cms (17 x 34 ins)
1959

MIKHAIL KHMELKO
Sketch for *The Greeting of the First Cosmonaut, Yuri Gagarin, on his Return to Earth*
Oil on canvas, 40 x 90 cms (16 x 35 ins)
1957

Plate L

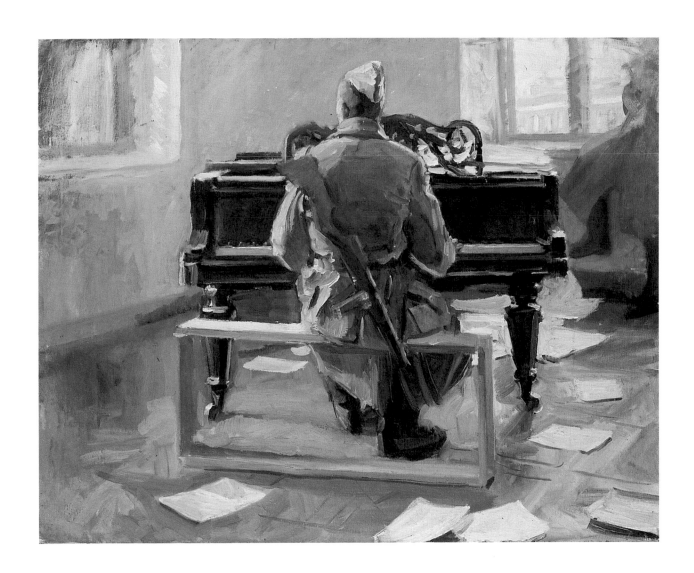

GEORGI MELIKHOV
Victory Day in Berlin
Oil on canvas, 80 x 100 cms (31 x 39 ins)
1960

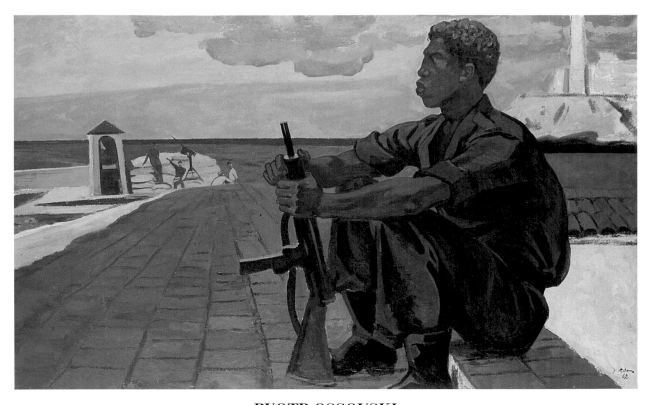

PYOTR OSSOVSKI
A Soldier of the Cuban Revolution
Oil on canvas, 126 x 210 cms (50 x 83 ins)
1962

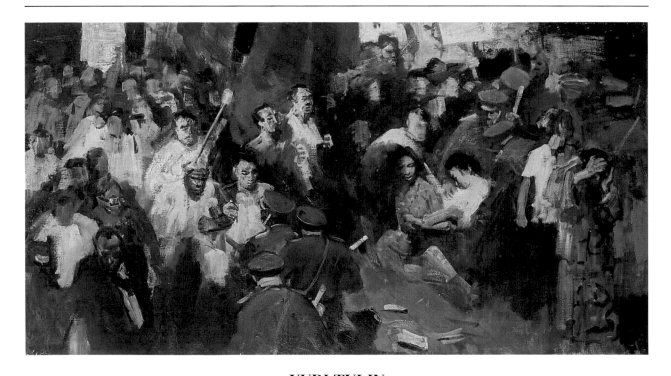

YURI TULIN
Sketch for *No to War!*
Oil on canvas, 70 x 131 cms (27 x 51 ins)
1962

Plate LIII

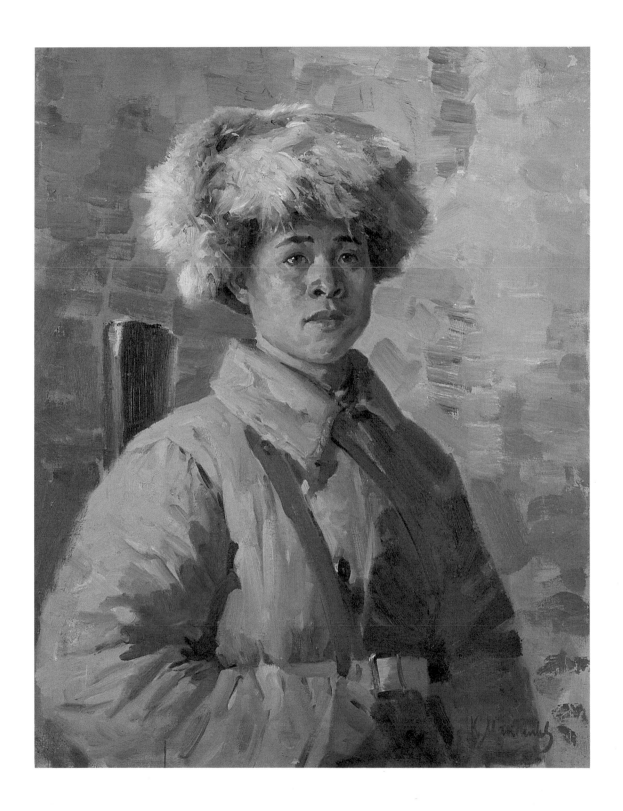

KONSTANTIN MAKSIMOV
A Warrior of the Chinese Revolution
Oil on canvas, 90 x 70 cms (35 x 28 ins)
1955

Plate LIV

PAVEL NIKONOV
Meat
Oil on canvas, 123 x 191 cms (48 x 75 ins)
1960-1

Plate LV

VIKTOR POPKOV
A Family in July
Tempera on canvas, 150 x 189 cms (59 x 74 ins)
1969

Plate LVI

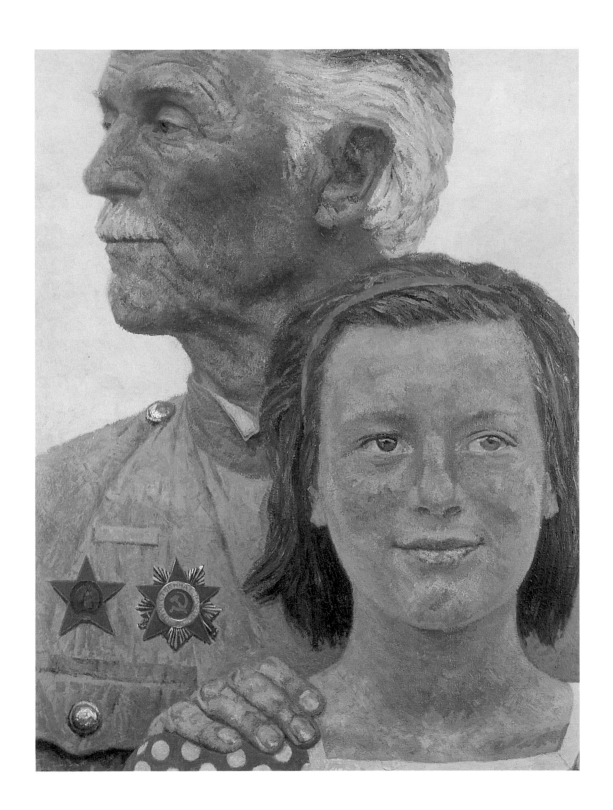

GELLI KORZHEV
Anxiety
Oil on canvas, 200 x 151 cms (79 x 59 ins)
1965-8

Plate LVII

85

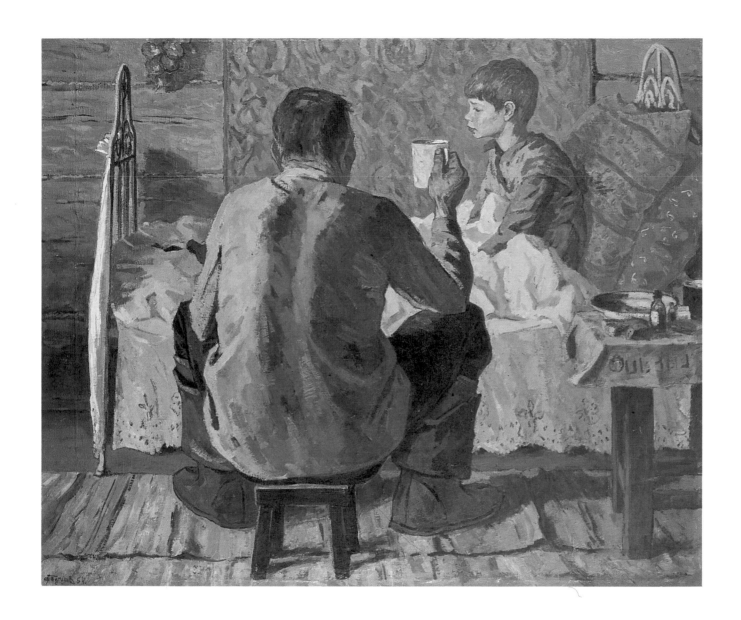

ANDREI TUTUNOV
The Fisherman and his Son
Oil on canvas, 119 x 146 cms (47 x 57 ins)
1964

Plate LVIII

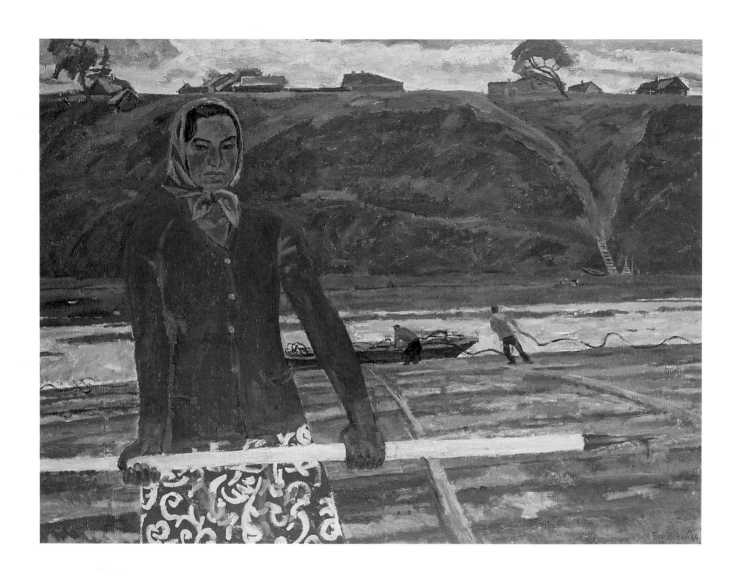

EDUARD BRAGOVSKI
Logging on the Vetluga
Oil on canvas, 151 x 201 cms (59 x 79 ins)
1964

Plate LIX

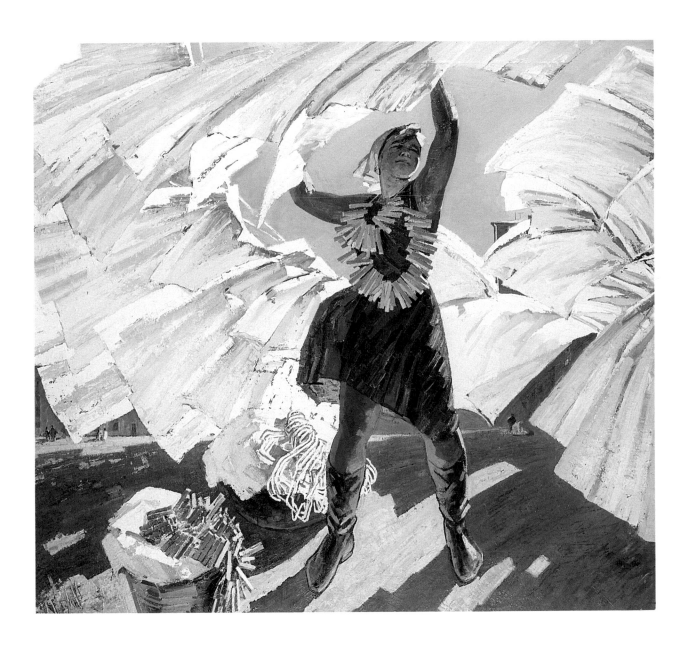

MAI DANTSIG
A Sunny Day
Oil on canvas, 189 x 208 cms (74 x 82 ins)
1965

Plate LX

NIKOLAI TIMKOV
Leningrad: the Petrograd Side
Oil on canvas, 101 x 171 cms (40 x 67 ins)
1964

NOTES

ENGINEERS OF THE HUMAN SOUL

1 Cited in Bowlt, J., *Russian Art of the Avant Garde. Theory and Criticism*, London, 1988, pp. 290-95. See also the longer abridged transcript of the proceedings in English in Zhdanov, A., et al., *Problems of Soviet Literature. Reports and Speeches at the First Soviet Writers' Congress*, New York, 1935.

2 Bowlt, Ibid.

3 Stalin is also on record as saying at this meeting: 'If the artist is going to depict life correctly, he cannot fail to observe and point out what is leading towards Socialism. So this will be socialist art. It will be Socialist Realism.' 'O Politike partii v oblasti literatury i iskusstva' in *Osnovy Marksistsko-Leninskoi Estetiki*, Moscow, 1958, p.111. The term Socialist Realism first appears to have been used in an article in the *Literaturnaya Gazeta* for 25 May 1932.

4 Bowlt, op. cit.

5 See Fitzpatrick, S. (ed.), *Cultural Revolution in Russia 1928-31*, Bloomington, 1978.

6 Golomstock, I., *Totalitarian Art*, London, 1990.
Groys, B., *Gesamtkunstwerk Stalin. Die gespaltene Kultur in der Sowjetunion*, Munich, 1988.

7 *Zhizn iskusstva*, 1924, No.6, p.24.

8 Soviet art history books written in the 1920s had adopted a similar line in writing the history of Russian art. See Rabinovich, I. S., *Trud v Iskusstve*, Moscow, 1927, which uses the period between the revolutions of 1848 and 1917 to categorise modern European art and then constructs a strongly tendentious view of art history in Russia based on the work of The Itinerants alongside it. Fedorov-Davidov's book on the Symbolist and art nouveau period before the Revolution was simply entitled *Russkoe Iskusstvo Promyshlennogo Kapitalizma* (Russian art [of the period of] Industrial Capitalism), Moscow, 1929.

9 Groys, op. cit., passim. Golomstock also highlights the fact that two separate and almost unconnected histories have been written in eastern and western Europe. Western histories and encyclopaedias of art barely mention Socialist Realism if at all; Soviet commentators such as Mikhail Lifshits, on the other hand, have regarded Modernism as a development of Fascism. See Lifshits, M., and Reinhardt, L., *The Crisis of Ugliness. From Cubism to Pop Art*, Moscow, 1968, and *Art and the Contemporary World*, Moscow, 1973.

1 James, C. V., *Soviet Socialist Realism. Origins and Theory*, London, 1973 gives a useful analysis of the theoretical background. Lenin's article and a number of other seminal documents are also translated in the appendices.

11 *OSt* (The Society of Easel Painters) was one of the leading progressive realist groups in the 1920s. Cullerne Bown, M., *Art under Stalin*, Oxford, 1991, pp. 41-53, gives a helpful breakdown of the orientations of the different artists' groups.

12 Between 1928 and 1932 Party membership virtually trebled, increasing from 1.3 to 3.5 million.

13 Sery, G., 'Monastyr na Gossnabzhenii', *Leningradskaya Pravda*, 10 June 1926.

14 Quoted in Kovtun, E. F., et al., *Avangard, Ostanovlenyi na Begu*, Leningrad, 1989, unpaginated.

15 Ibid. Sergei Kirov was the Communist Party Secretary in Leningrad and leader of the opposition to Stalin. He was assassinated in 1934 under Stalin's orders; a purge took place in Leningrad immediately afterwards 'to find the culprits.'

16 The work of both the constructivist, Gustav Klutsis, and the *OSt* member, Alksandr Deineka, was published in the magazine early in 1931.

17 The text of this decree is printed in Cullerne Bown, op. cit., p. 234.

18 Cullerne Bown, op. cit., traces the history of the Artists' Union from this time until the 1950s, pp.85-89.

19 Rakitin, V., 'The Avant-Garde and Art of the Stalinist Era,' in Günther, H. (ed.), *The Culture of the Stalin Period*, London, 1990, p.178.

20 Golomstock, op. cit., p. 112.

21 Ibid, pp. 220-24.

22 The first Five Year Plan had been adopted by the 15th Party Conference in August 1928. Its main aims were the collectivisation of agriculture and the construction of an infrastructure for heavy industry. By the end of 1931, 20 million individual farms had been amalgamated into 250 thousand collective farms. In the whole process it has been estimated that famine and persecution claimed the lives of as many as 10 million peasants.

23 Aleksandra Kollontai, the only woman in Lenin's government, was an important theorist, organiser, novelist and a champion of womens' rights.

24 Golomstock, op. cit., pp. 218-19.

25 In reality Stalin was short, pockmarked and had a withered arm. None of these characteristics was ever depicted in the vast number of portrait paintings and sculptures that were made of him, and, had they been, the artist would certainly have been imprisoned. See Cullerne Bown, op. cit., p. 99.

26 A record of unofficial or dissident art can be found in Doria, C. (ed.), *Russian Samizdat Art*, New York, 1986; Glezer, A., *Kunst gegen Bulldozer*, Frankfurt a/M, 1982; Golomstock, I., and Glezer, A., *Unofficial Art from the Soviet Union*, London, 1977; Sjeklocha, P., and Mead, I., *Unofficial Art in the Soviet Union*, Los Angeles, 1967.

HOW IS THE EMPIRE?

1 I. V. Stalin, *Sochineniya*, Vol. 7, OGIZ, Moscow, 1947, p. 138.

2 I. V. Stalin, *Sochineniya*, vol. 12, Gos. Izd. Pol. Lit., Moscow, 1953, p. 367.

3 I. V. Stalin, *Sochineniya*, vol. 13, Gos. Izd. Pol. Lit., Moscow, 1951, p. 7

4 Cullerne Bown, *Art under Stalin*, p. 56.

5 Until the Khrushchev thaw Bazhbeuk-Melikyan used the russified form of his surname, Bazhbeuk-Melikov, in an attempt to avoid discrimination (presumably from Georgians).

6 See Cullerne Bown, *Art under Stalin*, pp. 141-163 for an account of Soviet art during the war.

7 Grigori Ulko, a Russian artist living in Samarcand, has related to me the following anecdote:- The Russian artists who lived in Samarcand during the war - many of them famous names - each presented a work to the local artists' union as a token of thanks. The head of the Samarcand union in the post-war years, unwilling to take responsibility for all these paintings and drawings, which bore a high nominal value and required looking after, organised a commission to write them off. This done, he made a bonfire of the lot.

8 Sysoev, P. M., et al., *Akademiya Khudozhestv SSSR, Pervaya i Vtoraya Sessii*, Moscow, Akademiya Khudozhestv SSSR, 1949, p. 17.

9 Ibid.

10 Manizer, M. G., (ed.), *Akademiya Khudozhestv SSSR, Tretya Sessiya*, Moscow, Akademiya Khudozhestv SSSR, 1949, p. 110.

11 Ibid., p. 115.

12 Ibid., p. 129.

13 Ibid., p. 122.

14 Mikhail Khmelko told me about this objection to his painting - he claimed it was Stalin's - when I visited him in Kiev in 1990.

THE THAW

1 A number of claims have been put forward for the appearance of unofficial artists and groups before Stalin's death. Eli Belyutin dates some of his abstract sculptures from the late 1940s, although there is no independent corroboration of his claims. An interesting document would appear to be *Letopis Artisticheskogo Podpolya v SSSR 1946-1966* (*A Chronicle of the Artistic Underground in the USSR 1946-66*), a samizdat document mentioned in *The Quest for Self-Expression*, p. 48. Reaction against Stalinist norms in the official art world from about 1950 are discussed in Cullerne Bown, *Art under Stalin*, pp. 224-5.

2 *The Thaw* is about the life and work of two fictitious artists of opposing type: Pukhov, a party-line painter; and Saburov, a free spirit.

3 The Surikov Institute not only produced nearly all of Moscow's leading official artists in the post-war decades, but also outstanding members of the artistic underground such as Ilya Kabakov, Erik Bulatov, Oleg Vasilev and Ivan Chuikov, all of whom appear to have put the rigorous academic training they received to good use.

4 The changing mood of the Soviet art world in the period between Stalin's death and the artists' 1957 congress is discussed in Cullerne-Bown, *Art under Stalin*, pp.225-6.

5 There were two egregious tendencies in the early 1950s: first, the so-called 'pompous' (*paradnyi*) or 'laudatory' (*aplodismentnyi*) manner which glorified the leadership; and second, the moralistic-didactic genre which enlivened the image of the complete social harmony of Soviet society with the portrayal of schoolboys who had received poor marks, of KomSoMol members who had neglected their duties, of young workers who had not carried out their planned task, and of other temporary, unwitting infringers of the rules of the great Soviet hostel.

6 Kamenski published the term Severe Style for the first time in his article 'Realnost Metafory' (*Tvorchestvo* 8/1968 pp. 13-15), although he had used the phrase more than once in discussions in the period 1957-61.

7 Kamenski, *Romanticheskii Montazh*, p. 196.

8 Deineka himself probably appreciated the enthusiasm of these young artists for his work. He bought a painting by Nikonov in 1957.

9 The artists accompanying Khrushchev at the Manezh were Vladimir Serov, Sergei Gerasimov, Boris Ioganson, Ekaterina Belashova and Dmitri Mochalski..

10 What is claimed to be a verbatim account of Khrushchev's visit was published as 'Khrushchev on Modern Art' in *Encounter*, 20, April 1963, pp. 101-3.

11 An interesting, if partisan, account of the Manezh affair and its aftermath is provided by Eli Belyutin's unpublished manuscript, *Khrushchev i Manezh*.

12 Serov, V., *V Borbe za Sotsialisticheskii Realizm*, Moscow, 1963, p. 191.

13 Ibid., p.222.

14 Kamenski, *Romanticheskii Montazh*, pp. 190-1.

15 The sketch for this painting, showing an image of Stalin on the easel, is preserved by the artist.

BIOGRAPHIES

Mikael ABDULLAEV was born in Baku in 1921. He studied at the Azerbaijan Art-Tekhnikum 1935-9 and at the Surikov Institute, Moscow, 1939-49. During the war he designed a number of posters. He has painted several thematic pictures, most of which are in the Azerbaijan Art Museum, and also illustrated books by Maksim Gorki and Azeri authors. He was made a member of the USSR Academy of Arts in 1958 and a People's Artist of the USSR in 1963; in 1959 he received an Order of Lenin. Abdullaev works in Baku.

Nikolai ANDRONOV was born in Moscow in 1929. He studied at the Moscow Intermediate Art School until 1948 and at the Surikov Institute, Moscow, 1948-54. He worked in Kuibyshev 1954-6 before settling in Moscow. In the late 1950s he emerged as one of the leading exponents of the Severe Style. In 1960 began to work as a monumental artist, since when the influence of old Russian religious painting, and in particular the frescoes in the Ferapontovo monastery near Vologda, has becaome increasingly evident in his work.

Mariam ASLAMAZYAN was born in the village of Bash-Shirak in northern Armenia in 1907. As a schoolgirl she attended art classes in a studio run by Yuliya Verzhbitskaya in Leninakan. In 1926 she entered the Erevan Art-Tekhnikum where she was taught by Sedrak Arakelyan. Here she became familiar with the school of Armenian painting which had formed since the beginning of the century and whose leading figure was Martiros Saryan. In 1929 she moved to Moscow and was accepted at *VKhuTeIn*. This brought her into contact with avant-gardists such as Aleksandr Drevin and Nadezhda Udaltsova; but only briefly, because a year later she transferred her studies to the All-Russian Academy of Arts in Leningrad, where she worked under the direction of Kuzma Petrov-Vodkin. She graduated from the Academy in 1932 but stayed on for a further two years as a postgraduate. She stayed in Leningrad and worked part-time as a teacher until the outbreak of war in 1941. Then she moved to Erevan and, after the Nazis were driven out, settled in Moscow where she works today, although she still maintains a home in Erevan.

Nikolai BASKAKOV was born in Astrakhan in 1918. He studied at Astrakhan Art College 1933-9 and at the Repin Institute, Leningrad, 1945-51. His diploma work was carried out under the guidance of Boris Ioganson. In the 1950s he painted a number of genre paintings on the theme of work. Baskakov works in St. Petersburg.

Eduard BRAGOVSKI was born in Tiflis (today Tbilisi) in 1923. In 1927 his family moved to Moscow. He studied at Vilnius Art Institute 1946-7 and at the Surikov Institute, Moscow, 1947-53. In the 1960s he developed a decorative manner drawing on the example of the Severe Style. He has been a great influence on artists of his generation in Moscow. Bragovski today is chairman of the painting section of the Moscow artists' union.

Erik BULATOV was born in Sverdlovsk in 1933. His father, who died in the war, instilled in the young Erik the idea that he would become an artist. He studied at the Surikov Institute, Moscow, 1952-8. Although he was an able student, he realised that what he had been taught was a narrow and distorting view of art. In the late 1950s and early 1960s he re-educated himself under the particular influence of Robert Falk and Vladimir Favorski, two artists who had been prominent in the 1920s and thereafter excluded from Soviet artistic life. In the 1960s and 1970s, Bulatov established himself as one of the leading Soviet non-conformist painters. Today he works in New York.

Semyon CHUIKOV was born in Pishpek (now Frunze), Turkestan (today Kirgizia) in 1902; he died in Moscow in 1980. In 1914 the Chuikov family, which had moved to Verny (today Alma Ata), in Kazakhstan, split up and Chuikov was left to fend for himself. In the summer he worked to earn money and in the winter went to school, where he received his first drawing lessons from a graduate of the Odessa Art School, Nikolai Khludov. In 1920 he decided finally to become an artist and, with the support of *KomSoMol* (the Communist League of Youth), was given a place at the Turkestan regional art school in Tashkent, the capital of Uzbekistan. This entailed another move; indeed, Chuikov had to travel across Kazakhstan for 29 days before he reached the nearest railway station. In Tashkent Chuikov met his future wife, the painter Evgeniya Maleina. The next year ambition took him and Maleina to Moscow where they entered *RabFak*, the workers' faculty attached to *VKhuTeMas*. In 1924 he entered Robert Falk's studio there, where he studied until 1928. The young Chuikov met with success in Moscow. In 1927, at the Jubilee Exhibition of the Art of the Peoples of the USSR, he became the first Kirgizian artist to sell a painting to the Tretyakov Gallery. After graduating from *VKhuTeIn* in 1929 he was employed as a teacher, first in Moscow and then in Leningrad. In the early 1930s, after artists were required to enter a single

union, Chuikov was given the task of setting up a Kirgiz artists' union. This he did in 1934, and was chairman of the union 1934-7 and 1941-3. Although he was a firm fixture in the art establishment during the 1930s and 1940s, and received a Stalin Prize in 1949, he belonged to the liberal wing of that establishment. Chuikov's invariable subject, at least until the 1950s, when he made a trip to India, was the life and landscape of his native Kirgizia.

Mai DANTSIG was born in Minsk in 1930. He studied at Minsk Art College 1947-52 and at the Surikov Institute, Moscow, 1952-8. After graduation in Moscow, Dantsig returned to Minsk, where in the 1960s he began to explore formal ideas similar to those of the Severe Style artists (with whom he had studied). Dantsig's work is distinguished by its large scale - even for small or intimate subjects - and its broad execution.

Konstantin DOROKHOV was born in Smolensk in 1906; he died in Moscow in 1960. He studied at the Moscow *VKhuTeMas/VKhuTeIn* 1923-30 under Aleksandr Shevchenko, David Shterenberg and others. In the 1930s he painted mostly portraits of young people; in the 1940s and 1950s he also tackled thematic paintings. In the late 1940s he received public criticism from the Academy of Arts for his failure to paint in the approved academic style.

David GABITASHVILI was born in Tbilisi in 1928. He studied at the Tbilisi Academy of Arts 1946-52. He has painted a number of thematic pictures dealing with youth subjects. He works in Tbilisi.

Aleksandr GERASIMOV was born in Kozlov (now Michurinsk) in 1881; he died in Moscow in 1963. He graduated from the Moscow College of Painting, Sculpture and Architecture in 1915. He was a member of *AKhRR*, the leading group of realist artists, 1925-32. He was chairman of the Moscow artists' union 1937-9, and of the organising committee (*Orgkomitet*) of the planned Union of Artists of the USSR 1939-54. He was the first President of the USSR Academy of Arts, presiding from 1947-57 until compelled to resign by Khrushchev. Gerasimov was awarded Stalin prizes in 1941 for *Stalin and Voroshilov in the Kremlin*; in 1943 for *A Hymn to October*; in 1945 for *Group Portrait of the Oldest Artists*; in 1948 for a number of works. Gerasimov is the artist most closely associated with the party line in Soviet art of the Stalin period; but he himself is more than a

two-dimensional ogre. In his paintings of a Russian communal bath he attempted to maintain a personal response to life that is in striking contrast to his many contributions to the Stalin cult.

Sergei GERASIMOV was born in Mozhaisk in 1885; he died in Moscow in 1964. He is known as a painter of landscapes and thematic pictures, and as a book illustrator. He graduated from the Moscow College of Painting, Sculpture and Architecture in 1912. In the 1920s he was a member of more than one artists' group: *Makovets* 1922-5, the Society of Moscow Painters (*OMKh*) 1926-9, The Association of Artists of the Revolution (*AKhR*) 1931-2. He taught at the Moscow *VKhuTeMas/VKhuTeIn* 1920-9, at the Moscow Polygraphic Institute 1930-6, at the Surikov Institute 1936-50 (as director 1946-8), at the Stroganov College (*MVKhPU*) 1950-64. He was chairman of the Moscow artists' union 1939-52. In the post-war years Sergei Gerasimov, as chairman of the Moscow artists' union and director of the Surikov Institute, came under fierce attack from the Academy of Arts because of his relatively liberal views on art. In 1948 he was compelled to resign as director of the Surikov Institute. Although he painted a number of well-known thematic pictures, he was above all a landscape painter, and as such had considerable influence on young artists. In the Khrushchev thaw he was made First Secretary of the newly-formed USSR Union of Artists, a post he held till his death in 1964.

Pavel GLOBA was born in the village of Verguny near Kiev in 1918. He studied at in Siberia at the Omsk Artistic-Pedagogical Tekhnikum 1933-7 and at the All-Russian Academy of Arts, Leningrad, 1937-9. From 1939-45 he was a member of the Grekov Studio of military artists.

Adolf GUGEL was born in Vienna in 1915. He graduated from Vitebsk Art College in 1940. He is the author of many thematic pictures, some of them painted with his wife, Raisa Kudrevich (q.v.). He works in Minsk.

Boris IORDANSKI was born in Kovrov in 1903; he died in Moscow in 1987. He studied at the Moscow *VKhuTeMas/VKhuTeIn* 1922-30. He was a member of the Association of Artists of the Revolution (*AKhR*) 1928-31; of the Russian Association of Proletarian Artists (*RAPKh*) 1931-2. He worked as a monumental artist, and in the post-war period he carried out a number of big commissions with Georgi Rublyov (q.v.).

Mikhail KHMELKO was born in Kiev in 1919. He graduated from Odessa Art Tekhnikum in 1940 and Kiev Art Institute in 1946. Khmelko was awarded Stalin Prizes in 1948 for *To the Great Russian People* and in 1950 for *The Triumph of the Conquering People*. During the 1940s and 1950s he was the outstanding painter of grand ceremonial pictures in the whole of the USSR. He works in Kiev.

Akhmed KITAEV was born in Yunich,

Mordovia, in 1925. He studied at the Moscow State Art Institute, 1940-5. He is the author of many highly-finished genre paintings, and of the most-reproduced painting of Lenin. He works in Moscow.

Gelli KORZHEV was born in Moscow in 1925. His father was an architect and member of the Association of New Architects (*AsNovA*) - the leading avant-garde grouping of the 1920s. He studied at the Moscow Intermediate Art School 1939-44 and at the Surikov Institute, Moscow, 1944-50, graduating from Sergei Gerasimov's studio. Soon after graduation he won acclaim with his painting *In the Days of War* (1954); but Korzhev's personal voice really emerged in 1959 with the painting *Lovers* (*Vlyublennye*), an image of a middle aged couple sitting together on the seashore, sunk in memory. Here for the first time the archetypal Korzhev protagonist emerged: a middle-aged or elderly man who bears the burden of heavy, even traumatising experience. The series of paintings entitled Scorched by the Fire of War, executed in the mid-1960s, established Korzhev as the most powerful realist of his generation. Gelli Korzhev works in Moscow.

Mikhail KOSTIN was born in the Rostov region in 1918; he died in Moscow. He graduated from the Moscow State Art Institute during the war. At the end of the 1940s he taught at the Vladivostok Art College and was chairman of the local union of artists. In the 1950s he returned to Moscow, where he lived and worked for the rest of his life.

Zinaida KOVALEVSKAYA was born in Volsk in 1902; she died in Samarcand in 1972. She studied at Kazan Art Tekhnikum 1922-7 under Nikolai Feshin and Pavel Benkov. Here she struck up a close relationship with Benkov, who was a long-standing family friend; whether he was at any time her lover is uncertain, but it seems likely. In 1930 Benkov decided to settle in the ancient town of Samarcand, and Kovalevskaya followed him there. She worked first in the ethnographic department of the Uzbek State Scientific Research Institute and then as a teacher at the Samarcand Art College (set up by Benkov) from 1932-44. Kovalevskaya painted scenes of Uzbek life. Her painting *In the Box* (1937), showing Uzbek women enjoying a night out at the Bolshoi Theatre, became widely known in Moscow after it was shown there in 1939 at the exhibition, The Industry of Socialism. Her companion, Benkov, died in 1949, and Kovalevskaya continued to live in their house until her own death in 1972. A room is devoted to her work in the Tashkent Art Museum .

Raisa KUDREVICH was born in Minsk in 1919. She studied at Vitebsk Art College 1937-41, where she met her husband, Adolf Gugel (q.v.). She is the author of many thematic pictures; some of them painted with Gugel. She works in Minsk.

Aleksandr LAKTIONOV was born in Rostov-on-Don in 1910; he died in Moscow in 1972. He studied at Rostov art school 1926-9; at the

All-Russian Academy of Arts, Leningrad, 1932-8, and as a post-graduate at same place 1938-44. Laktionov was Isaak Brodski's favourite pupil and an arch-exponent of the academic style which came into its own after the war. He was awarded a Stalin prize in 1948 for *A Letter from the Front*.

Boris LAVRENKO was born in Rostov-on-Don in 1920. In 1936 he entered Rostov Art College; in 1940, before graduating, he was called-up by the army. He survived the whole war as a simple soldier, ending up in Berlin. He studied at the Repin Institute, Leningrad, 1946-52. In 1952 he began a course of post-graduate study under Boris Ioganson. He painted several genre pictures in the 1950s, most of which dealt with young subjects. Lavrenko works in St. Petersburg.

Konstantin MAKSIMOV was born in the village of Shatrovo, near Sereda (today Furmanov) in 1913. He studied at Ivanovo-Voznesensk Artistic-Pedagogical Technikum from 1930; at the Moscow State Art Institute 1937-42. He was awarded Stalin prizes in 1950 for *Leading People of Moscow in the Kremlin* (brigade work); in 1952 for *A Meeting of the Praesidium of the USSR Academy of Sciences* (brigade work). He has taught at the Peking Academy of Arts 1955-7; at the Surikov Institute from the 1940s to the present day.

Vyacheslav MARIUPOLSKI was born in Omsk in 1906; he died in Moscow in 1986. He studied at the Moscow *VKhuTeIn* 1925-30. In the 1930s he worked in Moscow. During the war he lived in Omsk, moving back to Moscow afterwards. In 1950 he was awarded a Stalin Prize for his picture *A Leader in the Pioneers* (*Vozhataya*).

Georgi MELIKHOV was born in Kharkov in 1908; he died in Kiev. He graduated from the Kiev Art Institute in 1941. In 1948 he was awarded a Stalin Prize for his painting *The Young Taras Shevchenko Visiting the Artist K. P. Bryullov*.

Aleksei MERZLYAKOV was born in 1924; he died in Moscow in the 1960s. He studied at the Surikov Institute, Moscow, graduating in the early 1950s. He worked in Moscow.

Vruir MOSESOV was born 1911. He worked in Leningrad. He painted more than one work devoted to the young Stalin around 1950 (e.g. *I. V. Stalin in the Years of his Youth*, illustrated in the catalogue to the 1950 All-Union Art Exhibition).

Anatoli NIKICH (NIKICH-KRILICHEVSKI) was born in Petrograd in 1918. He studied at the Moscow State Art Institute 1935-42. He specialises in still-lifes. He works in Moscow.

Pavel NIKONOV was born in Moscow in 1930. He studied at Moscow Intermediate Art School 1942-9 and at the Surikov Institute, Moscow, 1949-56. Nikonov was struck by the contrast between the Western and Soviet exhibitions at the 1957 international youth festival held in Moscow, where the

homegrown art struck him as 'dead' and as 'tortuous academicism'. He was one of the originators of the Severe Style. His first paintings were influenced by Deineka; but he was soon looking further afield for inspiration. *Geologists* (1962) harked back to the painting of repressed artists such as Drevin and Shchipitsyn. In the 1960s, Nikonov faced a decade of official criticism and suspicion; but it was also a fertile period, during which he became well acquainted with the work of forgotten artists of the pre-war days: Shchipitsyn, Drevin, Udaltsova, Nikritin and others. Since the 1970s, Nikonov has been regularly visiting the Russian village of Aleksino. Over two decades he has seen a once-flourishing village die as the young generation moved to the towns. Many of his most recent works are an elegy to this departing world. A one-man show of his work was held in Moscow in 1991.

Pyotr OSSOVSKI was born in the village of Malaya Viska, near Kirovgrad, in 1925. He studied at the Moscow Intermediate Art School 1940-4 and at the Surikov Institute, Moscow, 1944-50. He was one of the originators of the Severe Style. He works in Moscow.

Vladimir PETROV was born in Astrakhan in 1920. He studied at Astrakhan Art College 1934-9, and afterwards at the Latvian Academy of Arts in Riga. On graduating in 1949 he moved to Tashkent, where he has worked ever since. He is the author of innumerable thematic pictures.

Viktor POPKOV was born in Moscow in 1932; he died there in 1974, shot by a security guard by mistake. He studied at the Moscow Artistic-Graphic Pedagogical College 1948-52; at the Surikov Institute, Moscow, 1952-8. Popkov's early paintings were influenced by Deineka in their pared-down monumentality. In 1961 a new lyricism entered his work, evident in the intensification of local colour, more intuitive simplifications of form and increasingly personal subject-matter. A trip in 1963 to Ferapontovo, the site of outstanding old religious frescoes, confirmed Popkov in his decision to abandon realism and take a path of formal exploration. Like many of his contemporaries, he turned to subjects he found in the Russian countryside. The most important cycle of paintings he completed in the 1960s was entitled The Mezen Widows, a series of images of women bereaved by the war, which was conceived after a trip to the Mezen region of Russia in 1966. His work signified a complete break, in both form and content, from the dogmas of Socialist Realism. He was perhaps the greatest single influence on the generation of young painters which emerged in the 1970s.

Viktor PUZYRKOV was born in Dnepropetrovsk in 1918. He studied at Dnepropetrovsk Art College 1936-8; at Kiev Art Institute 1938-41, 1944-6; at the Surikov Institute while in evacuation in Samarcand 1942-4. He has taught at Kiev Art Institute from 1948 to the present day. Puzyrkov was awarded two Stalin prizes: in 1948 for *Black*

Sea Sailors; in 1950 for *Stalin on the Cruiser 'Molotov'*. He is the author of many paintings of maritime subjects.

Georgi RUBLYOV was born in Lipetsk in 1902; he died in Moscow in 1975. He studied at the Moscow *VKhuTeMas/VKhuTeIn* 1923-9. He worked on public decorations with Tatlin and others in the 1930s. He was one of the liberal voices in Stalin's art establishment and, as deputy chairman of the Moscow artists' union in the late 1940s, he was sacked after allowing 'cosmopolitan' views to be expressed during a discussion of naturalism. In his early years he worked as an easel painter, but moved over to monumental art in the 1930s. He carried out several big commissions with Boris Iordanski (q.v.) in post-war years.

Vladimir SEROV was born in Emmaus (Tver region) in 1910; he died in Leningrad in 1968. He graduated from the Institute of Proletarian Visual Art in Leningrad in 1931. He was chairman of the Leningrad artists' union 1941-8; First Secretary of the Russian artists' union 1960-8; vice-president of the USSR Academy of Arts 1958-62; president 1962-8. He was awarded Stalin prizes in 1948 for *Lenin Declares Soviet Power*; in 1951 for *On Foot To V. I. Lenin*. Serov was one of the leading conservatives in the Soviet art world in the two decades after the war; he was closely associated with the persecution of non-conformist painters in the 1960s. He was also the author of a number of striking works of Socialist Realism, of which the best is *The Winter Palace Taken* (1954). Four times married.

Grigori SHEGAL was born in Kozelsk in 1889; he died in Moscow in 1956. He graduated from the Moscow *VKhuTeMas* in 1925. His painting *Leader, Teacher and Friend*, produced in more than one version, was one of the three most celebrated images of Stalin produced in the 1930s (along with Efanov's *An Unforgettable Meeting* and Gerasimov's *Stalin and Voroshilov in the Kremlin*). Shegal did much work as a teacher at the Surikov Institute and the Cinematographic Institute (*VGIK*).

Irina SHEVANDRONOVA was born in Moscow in 1928. She studied at the Moscow Intermediate Art School 1943-7 and at the Surikov Institute, Moscow, 1947-53. She specialises in young subjects. She works in Moscow.

Fyodor SHURPIN was born in Kuryakino (Smolensk region) in 1904; he died in 1974. He joined *RabFak* (Workers' Faculty) at the Moscow *VKhuTeMas* 1923, and studied at the Moscow *VKhuTeMas/VKhuTeIn* proper 1925-31. Best-known for his paintings of buxom peasant-madonnas, he was awarded a Stalin prize in 1949 for *The Morning of Our Motherland* (his only excursion into official portraiture), the most famous image of Stalin to be painted in the post-war period.

Antonina SOFRONOVA was born in Droskovo (Orlov region) in 1892; she died in Moscow in

1966. She studied in F. Rerberg's school, Moscow, 1910-3; in I. Mashkov's studio 1913-7. She took part in exhibitions of the Jack of Diamonds 1914, The World of Art 1917, The Group of 13 1931. She lived and taught briefly in Tver, 1920-1; thereafter she lived in Moscow. Sofronova was passed over when the Moscow Artists' Union was set up in 1932 and only became a union member after the war. She is best-known as a landscape painter. Sofronova worked throughout the Stalin period without acceding at all to official demands or the temptation of state commissions.

Vladimir STOZHAROV was born in Moscow in 1926; he died there in 1973. He studied at the Moscow Intermediate Art School 1939-45 and at the Surikov Institute, Moscow, 1945-51. Stozharov's paintings of life in old Russian towns and villages and in the Russian countryside, together with his ambitious still-lifes of the implements and fruits of peasant life, each bearing a brief eloquent title (*Bread, Kvas, Linen*) were of great significance to his fellow painters in the 1950s and 1960s. His work, like that of the Tkachev brothers, seemed to point a way out of artificial Stalinist Arcadia while not losing touch with the Russian realist tradition and the life of ordinary people. The return to peasant life - a life romanticised, perhaps, but not falsely glorified or distorted - initiated by Stozharov was an idea taken up in the work of many of the leading figurative painters of the 1960s.

Isaak TARTAKOVSKI was born in the village of Volochisko, near the town of Khmelnitsk in the Ukraine, in 1912. He graduated from Kiev Art Institute in 1951. He is best known as a portraitist. He works in Kiev.

Sergei and Aleksei TKACHEV were born in the village of Chugunovka in 1922 and 1925. They both graduated from the Surikov Institute, Moscow; Sergei in 1952 from Sergei Gerasimov's studio and Aleksei in 1951 from Dmitri Mochalski's studio. From the early 1950s they have worked as a team, sharing studios in Moscow and in the country and working on big paintings together. In the mid-1950s paintings by the Tkachev brothers, in their return to unvarnished peasant subjects and to the artistic principles of the Union of Russian Artists, pointed a way out of the impasse of Stalinist ideology and cold academic style. Their boldly-painted *Laundresses*, shown at the 1957 All-Union Exhibition, was one of the paintings of that year to significantly widen the boundaries of stylistic freedom for Soviet artists. The Tkachev brothers work in Moscow.

Nikolai TIMKOV was born in 1912. He studied under Isaak Brodski at the All-Russian Academy of Arts in Leningrad in the 1930s. He specialises in landscape paintings. He works in St. Petersburg.

Viktor TSYPLAKOV was born in the village of Burlinka, Ryazan region, in 1915; he died in Moscow in 1988. He graduated in 1942 from the Moscow State Art Institute, where he carried out his diploma work under the guid-

ance of Grigori Shegal (q.v.) His fellow-students remember him as perhaps the most talented painter of their generation. He painted several thematic works in the 1940s and 1950s, as well as landscapes showing the influence of Sergei Gerasimov (q.v.), with whom he went on painting trips.

Yuri TULIN was born in the village of Kedrovka, near Kalinin (now Tver), in 1921. He studied at the All-Russian Academy of Arts/Repin Institute, Leningrad, 1941-3 and 1944-50. He painted some highly-regarded thematic pictures in the 1950s and 1960s. His *Lena; 1912* received a medal at the 1957 international exhibition in Brussels.

Andrei TUTUNOV was born in Moscow in 1928. He studied at the Moscow Intermediate Art School 1940-7 and at the Surikov Institute, Moscow, 1948-54. In 1960 he was put in charge of an art studio in the little old town of Pereslavl-Zalessk. Writing of these years, he said: 'This wonderful old town gave shape for many years to my passion for little provincial places.' Many of the works he painted in the 1960s showed scenes around the river Oka, and the largest and most ambitious works often illustrated the lives of fishermen. In recent years, Tutunov's work has acquired a new religious content, with many images of churches, and even of angels, but it remains rooted in the Russian country-side. Andrei Tutunov works in Moscow.

Aleksei VASILEV was born in Samarcand in 1907; he died in Kishinev. He studied at the Moscow 1905 Art College 1926-8 and at the Moscow *VKhuTeIn* 1928-32. He worked for a post-graduate qualification at the Tretyakov Gallery 1932-5, but spent most of the 1930s travelling around the USSR. He lived for a while in the Soviet far east, in Komsomolsk-na-Amur and on the Chukotka peninsular, but spent most time in Frunze, Kirgizia. Here he developed a style based on that of Semyon Chuikov, the first head of the Kirgiz artists' union who had been his contemporary briefly at the Moscow *VKhuTeIn*. In 1940 he moved to the newly-annexed republic of Moldavia, and although his stay there was broken by the onset of the war, most of which he spent, along with other artists, in evacuation in Tashkent, he returned to the capital, Kishinev, in 1945. Vasilev painted a fair number of thematic pictures, but he was above all a landscape painter.

Frants ZABOROVSKI was born in Melbourne in 1915, the son of Russian emigrés. His parents returned to the USSR with the young Frants in the mid-1920s. He studied in Stalingrad 1927-34; at the Astrakhan Art Tekhnikum 1934-6; and at the All-Russian Academy of Arts/Repin Institute, Leningrad, where his study was interrupted by the war, 1936-47. Zaborovski is one of the outstanding Soviet monumental artists. He works in Saint Petersburg.

Ekaterina ZERNOVA was born in Moscow in 1900. She studied in F. Rerberg's studio, Moscow, 1915-18; and at the Moscow Free Art Studios/*VKhuTeMas* 1919-24. She was a member of the Society of Easel Painters from 1928, and later of *Izobrigada*. During her long career she has worked as a painter, monumental artist, book illustrator and poster designer. She works in Moscow.

Dmitri ZHILINSKI was born in Sochi in 1927. His great-grandmother was the mother, by her first marriage, of the famous nineteenth-century Russian painter, Valentin Serov. Zhilinski studied at the Moscow Institute of Applied and Decorative Art 1944-6; and at the Surikov Institute, Moscow, under two monumental artists, Pavel Korin and Nikolai Chernyshev, 1946-51. From 1945 he also visited and took the advice of the monumental and graphic artist, Vladimir Favorski. These artists, who all laid great stress on the role of line, influenced the development of Zhilinski's own style. During his student years he also looked closely at the work of Aleksandr Ivanov, the nineteenth-century academic master. In the 1950s he produced a number of genre paintings, of which *The Bridge Builders*, which shows the influence of Ivanov and of Aleksandr Deineka, was the most ambitious. From 1962-5 Zhilinski worked on his painting *A Family by the Sea*, which marked a change of style from straightforward realism to a self-conscious borrowing from early renaissance masters, and change of technique from oil to tempera. Zhilinski continued to paint thematic and compositional works, but unlike those of the 1950s they were now images of family and friends. As a teacher at the Surikov Institute (1953-71) he wielded considerable influence. The personal focus of his subject-matter and his passion for some of the neglected spots of art history, such as old Russian religious painting, were ideas taken up by young Moscow artists in the 1970s.

SUGGESTIONS FOR FURTHER READING

In English

Cullerne Bown, M., *Contemporary Russian Art*, Oxford, 1989

Cullerne Bown, M., *Art under Stalin*, Oxford 1991

Cullerne Bown, M., and Taylor, B., (eds.), *Art of the Soviets*, Manchester, 1992

Elliott, D., *New Worlds: Russian Art and Society 1900-37*, London, 1986

Golomstock, I., *Totalitarian Art*, London, 1990

Günther, H., (ed.), *The Culture of the Stalin Period*, London, 1990

James, C. V., *Soviet Socialist Realism, Origins and Theory*, London, 1973

Johnson, P., and Labedz, L., *Khrushchev and the Arts*, Cambridge Mass, 1965

London, K., *The Seven Soviet Arts*, London, 1937

Taylor, B., *Art and Literature under the Bolsheviks*, London, 1991, 1992 (2 vols.)

Roberts, N., (ed.), *The Quest for Self-Expression. Painting in Moscow and Leningrad 1965-90* (catalogue), Columbus, 1990

Contemporary Works in Russian

Beskin, O., *Formalizm v Zhivopisi*, Moscow, 1933

Bernshtein, B. M., et al. (eds.), *Izobrazitelnoe Iskusstvo Azerbaidzhanskoi SSR, Armyanskoi SSR, Belorusskoi SSR, Gruzinskoi SSR, Kazakhskoi SSR, Kirgizskoi SSR, Latviiskoi SSR, Litovskoi SSR, Moldavskoi SSR, RSFSR T. I, RSFSR T. II, Tadzhikskoi SSR, Turkmenskoi SSR, Uzbekskoi SSR, Ukrainskoi SSR, Estonskoi SSR*, (set of albums), Moscow, 1957

Gerasimov, A. M., *Za Sotsialisticheskii Realizm*, Moscow, 1952

Gorkii, A. M., *Gorkii ob Iskusstve*, Moscow, 1940

Konechna, G., (ed.), *50 Let Sovetskogo Iskusstva: Zhivopis*, Moscow 1967

Luppol, I., et al. (eds.), *Pervyi Vsesoyuznyi Sezd Sovetskikh Pisatelei, Stenograficheskii Otchet*, Moscow, 1934

Manizer, M. G. (ed.), *Akademiya Khudozhestv SSSR, Tretya Sessiya*, Moscow, 1949

Sysoev, P. M., and Kuznetsov, A. M., (eds.), *Akademiya Khudozhestv SSSR, Pervaya i Vtoraya Sessii*, Moscow, 1949

Sysoev P. M. and Shkvarikov, V. A. (eds.), *Mastera Sovetskogo Izobrazitelnogo Iskusstva: Zhivopis*, Moscow, 1951

Recent works in Russian

Kamenskii, A. A., *Romanticheskii Montazh*, Moscow, 1989

Papernyi, V., *Kultura Dva*, Ann Arbor, 1985

In Other Languages

Gervereau, L., (ed.), *Russie - URSS 1914-1991*, (catalogue), Paris, 1991

Groys, B., *Gesamtkunstwerk Stalin. Die Gespaltene Kultur in der Sowjetunion*, Munich, 1988

INDEX

ACKNOWLEDGEMENTS

We would like to thank the following collections for the use of black-and-white illustrations in this catalogue: I. I. Brodski Museum-Apartment, St. Petersburg (1); Tretyakov Gallery, Moscow (2, 8, 9, 13, 24, 29); Central Lenin Museum, Moscow (3, 5); Astrakhan Picture Gallery (4); Russian Museum, St. Petersburg (10, 11, 27, 28, 30); USSR Ministry of Culture (12); Museum of Ukrainian Art, Kiev (14, 17); Armenian Picture Gallery, Erevan (15, 19, 21); State Museum of the Karakalpakh ASSR, Nukus (16); Museum of Eastern Culture, Moscow (18); Museum of the Arts of Kazakhstan, Alma Ata (20, 25); Art Museum of Azerbaijan, Baku (26). We have been unable to locate 22, 23.

Design by WMCB, London Colour photography by FXP, London Printed by **Offset** Colour Print, Southampton